ARTIST'S PROJECTS YOU CAN PAINT

10 Favorite Subjects in Watercolors

by Barbara Jeffery Clay

international
artist

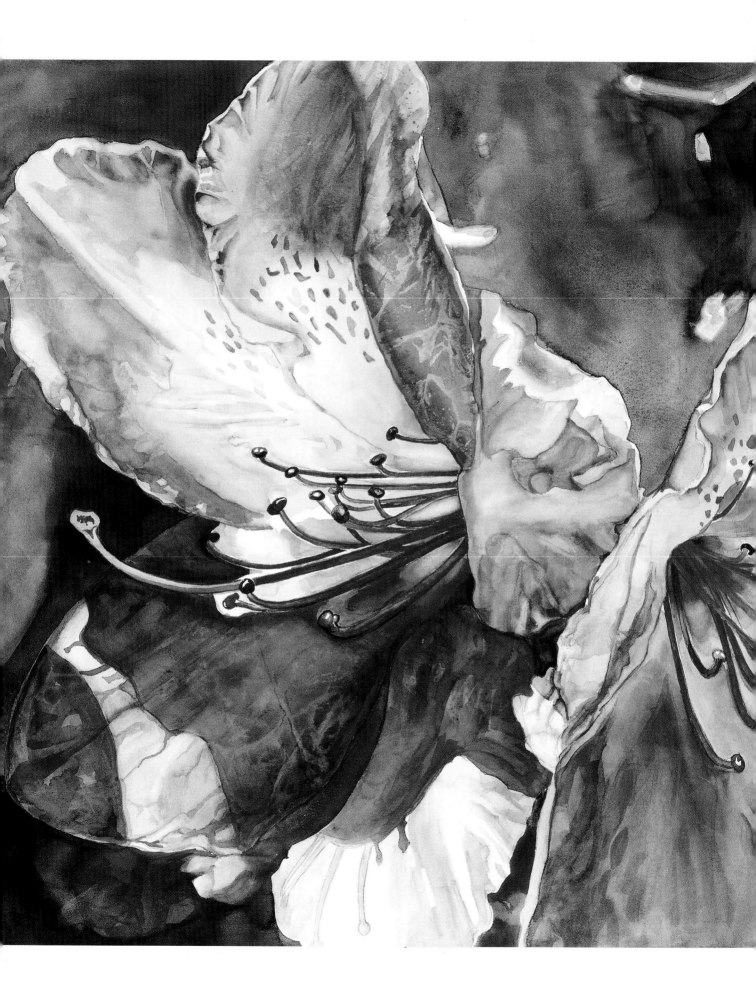

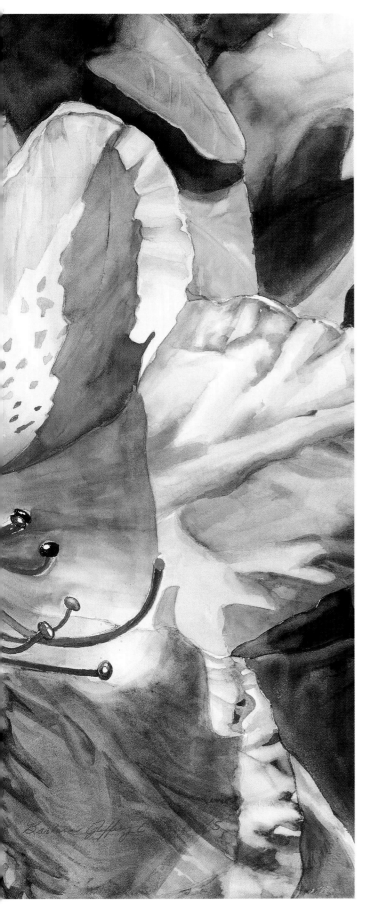

ARTIST'S PROJECTS YOU CAN PAINT

10 Favorite Subjects in Watercolors

by Barbara Jeffery Clay

Happy Painting!

Barbara Jeffery Clay, NWS

international **artist**

international
artist

International Artist Publishing, Inc
2775 Old Highway 40
P.O. Box 1450
Verdi, Nevada 89439

Website: www.internationalartist.com

Edited by Jennifer King and Nicole Klungle
Designed by Vincent Miller
Typeset by Nicole Klungle and Cara Herald

ISBN 1-929834-51-9

Printed in Hong Kong
First printed in 2004
08 07 06 05 04 6 5 4 3 2 1

Distributed to the trade and art markets
in North America by:
North Light Books,
an imprint of F&W Publications, Inc
4700 East Galbraith Road
Cincinnati, OH 45236
(800) 289-0963

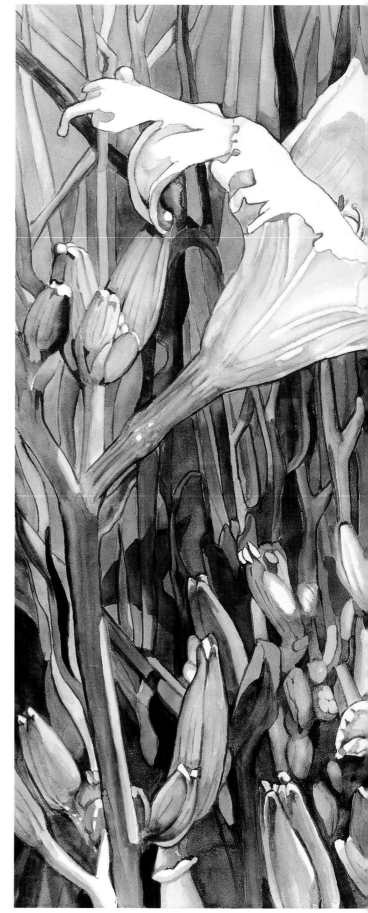

Acknowledgments

Those who helped me with the book:
Marilyn Bowden Gardner
Maria Granados Davila

Family support during the process:
Henry J. Clay, my husband and "go get 'em" support.
Meagan Jeffery, granddaughter and "write your own book, Nini!".
B. J. Clay, grandson and "you need to add a comma, Nini".
John and Michelle, Libby and Will Jeffery, my son's family, for giving
up "Nini" during the process.
Lyne Galloway, my sister, who said, "Show them how to see".
Pattie Robinson, my sister who is "So proud".

Support from friends:
Helgy J. White, "Go for it girl! You can do it!" help.
Deanna Kovacs, who has taken notes in my class and inspired me
to do this.

And to the many other friends, students and teachers who have so
influenced my life and my art, thank you.

Arroyo Seco Lilies

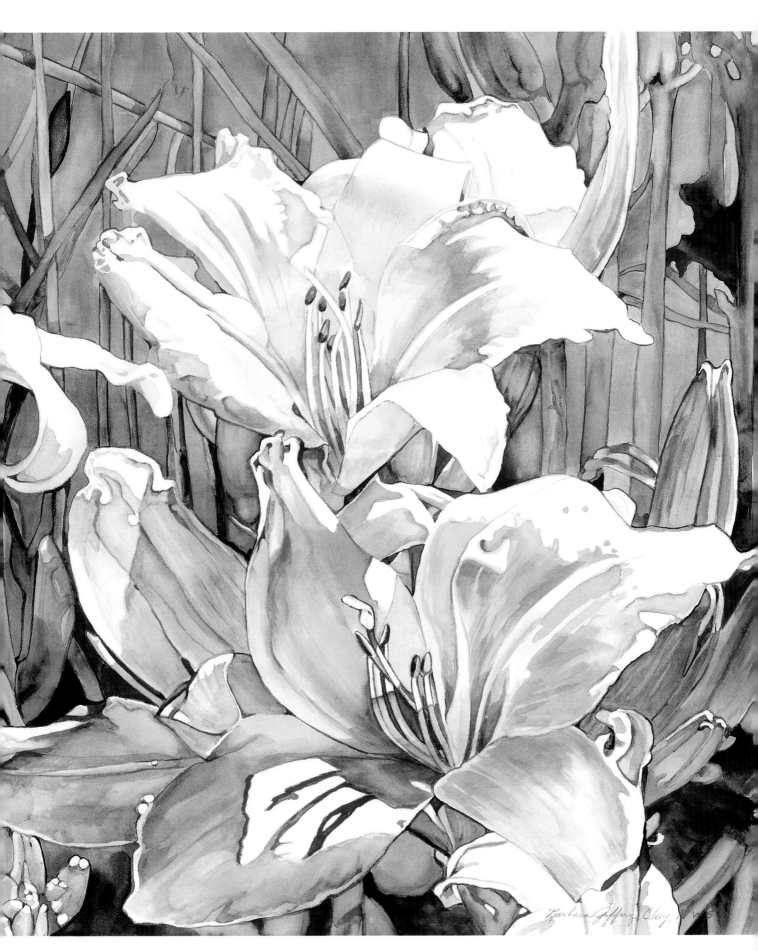

CONTENTS

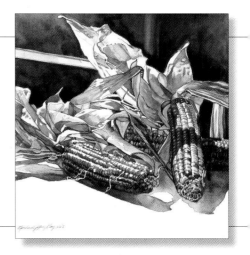

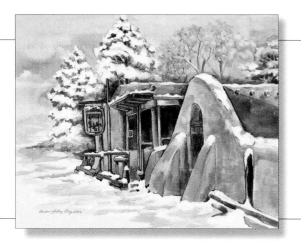

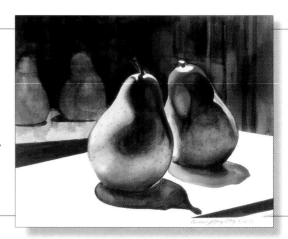

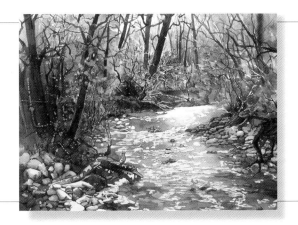

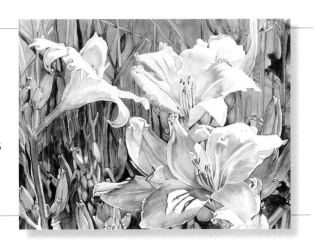

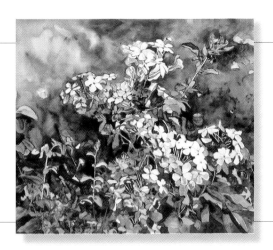

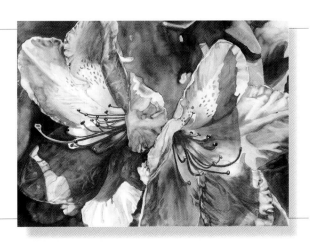

Althea

Meagan's Rose

INTRODUCTION

**YOU CAN DO IT! This book has been designed
to help you paint gorgeous watercolors that are exciting and fun.**

Painting is fun for all ages, young and old alike. Creating bright and delightful watercolor paintings from subjects found in nature is appealing to us all. Personally, I cannot stop painting. It is a love and excitement, a challenge and addiction in my life. The development of bright, pure and fascinating colors on the paper is a quest and passion that has endured. I am forever in awe of the process and the dynamic use of color that is possible on a plain white sheet of paper. White paper is very powerful in itself and a strong design element that enhances the power of color. Use it — love it — learn it and become skilled in the medium.

Why watercolor?

- Watercolor is fun. It plays with you and by itself. It is mobile, colorful, loose and light reflective on white paper. On a practical level, it's also easy to clean up after you have finished painting.

- Watercolor is an archival medium, which means that provided you use lightfast colors, quality, acid-free watercolor paper and conservation framing methods, there's no reason why your paintings won't stand the test of time. There are now many surfaces for watercolor such as paper, canvas, clay board and even a plastic surface.

- Watercolor dries very quickly, allowing you to continue to paint and refine, making it a time productive method of painting.

Blooming Artichoke

Afternoon Sun

There's plenty of help in this book

This project book has been designed to get you painting right away. Each project has a list of materials needed, and to start you off there is a clear preliminary drawing of each subject for you to sketch, trace or photocopy then transfer.

The steps are clear and concise, arranged logically with step by step pictures, specific color mixes, color charts and captions describing each stage in the process. There are hints and tips along the way that help you develop your understanding of watercolor technique, and each project has a clear list of challenges, techniques and learning points that build your skill level as you go. You'll find everything easy to understand so you can confidently tackle each project.

My only suggestion is that you read each project through before you start painting — that way you'll know what's going to happen next and there'll be no surprises!

My aim was to present a book that was both positive and instructional, with pictures and text to help you in the creation of your own painting.

Copyright warning!

Artist Barbara Jeffery Clay has generously supplied some exceptional paintings for you to follow. She knows that it is only through practice that skill is built. However, when you make your own version of these paintings, please respect the artist's copyright. Other than for educational purposes, it is against the law to make copies of another artist's work and pass it off as your own. So, by all means show your finished versions of the projects to your family and friends, but please do not sign them as your own, exhibit them, or attempt to sell them as your own work.

Materials you will need to paint every project in this book

It is important to use artist-grade materials if you want to achieve optimum results. You may save a few dollars at first by using student-grade supplies, but your painting will suffer. The colors will be weaker and duller, and you won't be able to control them as well. As well, paint won't lift or flow as well on poor-quality paper, and cheap brushes will shed bristles while making it difficult to manipulate your paint.

The generic pigment names for the paints are used, you should be able to find the same colors in many top-quality paint brands. Get to know your paints. Know the difference between staining and nonstaining pigments and how they affect your ability to lift color off the paper. Identify the granulating colors that give extra texture without the work. Understand the benefits of juxtaposing complementary colors, and know the difference between warm and cool colors.

My brushes are rounds and angled. Sable brushes are the most expensive, followed by squirrel hair then synthetic. Quality brushes hold a tremendous amount of paint, allowing you to cover large areas without returning to your palette for more pigment. This is particularly useful when you don't want the paint on the paper to dry before you can add more. Good brushes can also hold an extremely fine point for painting details, eliminating the need for small brushes that don't hold much pigment.

You can get good synthetic brushes if you prefer not to use animal hair.

When you reach a high level of comfort and familiarity with artist-grade materials, you will be able to focus all your energy on creating a beautiful painting rather than on the mechanics of manipulating paint on paper.

Brushes

6, 8, 12 Round
$\frac{1}{4}$", $\frac{1}{2}$", 1" angled brushes
small round detail brush
1" flat

Paper

140lb (300gsm) cold-pressed artist quality watercolor paper

18 Artist quality watercolors

Cadmium Yellow Light

Quinacridone Gold

Perinone Orange

Cadmium Red Light

Windsor Red

Permanent Alizarin Crimson

Permanent Red

Permanent Rose

Bordeaux

Violet

Ultramarine Blue

Cobalt Blue

Phthalo Blue

Phthalo Turquoise

Phthalo Green

Sap Green

Permanent Brown

Burnt Umber

Other Materials

- Stiff board
- Paper Towels
- Sponge
- Opaque white ink
- No. 2 pencil or graphite
- paper to transfer drawing onto your watercolor paper
- masking fluid
- masking tape

Use the color mix swatches as your guide

You'll find lots of example color mixes as you work through the projects.

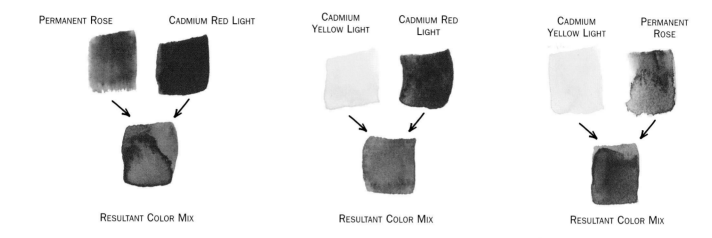

PERMANENT ROSE CADMIUM RED LIGHT

RESULTANT COLOR MIX

CADMIUM YELLOW LIGHT CADMIUM RED LIGHT

RESULTANT COLOR MIX

CADMIUM YELLOW LIGHT PERMANENT ROSE

RESULTANT COLOR MIX

For delicate hues

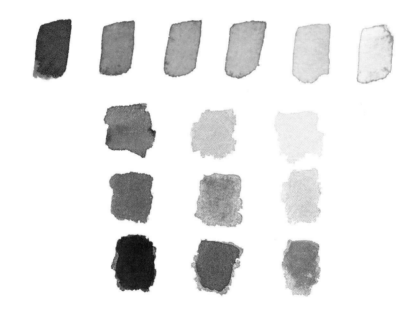

For strong hues

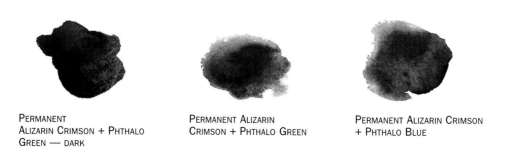

PERMANENT ALIZARIN CRIMSON + PHTHALO GREEN — DARK

PERMANENT ALIZARIN CRIMSON + PHTHALO GREEN

PERMANENT ALIZARIN CRIMSON + PHTHALO BLUE

Glazing methods and effects

Glazing is a very useful technique. It allows you to layer one color over another to enhance depth of color, change a color, create a new color or correct a color.

Glazing is often the best way to obtain an unusual color. Instead of mixing the wet pigments together on your palette and risk creating mud, you layer the colors separately on your paper.

No two glazed areas will have exactly the same color mix or value.

Layering creates natural variation and interest in your painting by allowing all the different colors and values to show through, particularly in the lighter values.

The key to successful layering is letting each layer dry before applying the next. Apply each layer in one stroke so as not to disturb the pigment in the bottom layers.

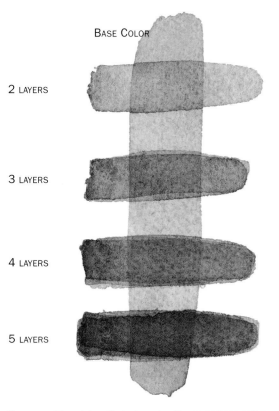

BASE COLOR

2 LAYERS

3 LAYERS

4 LAYERS

5 LAYERS

You can achieve intensity by layering the same base color.

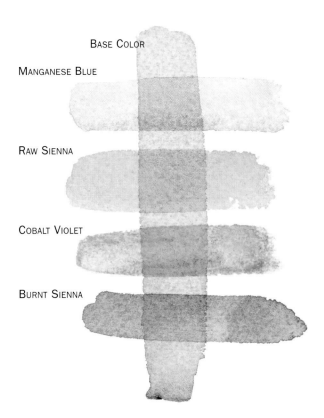

BASE COLOR

MANGANESE BLUE

RAW SIENNA

COBALT VIOLET

BURNT SIENNA

You can achieve transparent effects by layering different colors over your base color.

Important notes about drawing

Of course you can sketch the drawing for each project, but you may wish to photocopy, enlarge and then transfer the drawing to your watercolor paper. Here's what to do:

Prepare the drawing
- The drawing can be photocopied and enlarged for your personal drawing.
- The larger you can copy the drawing the easier it will be for you to paint the subject.
- 11 x 14" or larger would be a good size to work with.

Transfer the drawing to the watercolor paper
- Place and tape the photocopy to a lightbox or a window.
- Place and tape the watercolor paper over the photocopy.
- Draw in the subject using a regular #2 standard yellow (or a mechanical pencil will do).
- Carefully draw the subject onto the paper. Note that any erasing on the watercolor paper can cause a blotching of color when you start painting.
- Check your drawing at the end of the tracing process for accuracy. The correct drawing will save you time later when you start the painting.

PROJECT 1 HIBISCUS

Painting Dynamic Reds

Red is a strong, vibrant color that demands attention. It is also a primary color associated with drama and passion. As a warm color, red visually advances. When placed against cool colors, such as the background of this painting, red will come forward and the cool colors will appear to recede.

The challenges

- painting interesting and dramatic reds while keeping the colors realistic
- creating a variety of reds
- painting a delicate flower in a bold color

What you'll learn

- how to paint a flower with form, depth and structure
- how to paint the highlights and shadows caused by sunlight
- how to create a contrasting, complementary background

The techniques you'll use

- directional brushstrokes
- masking
- lifting color

Opaque and transparent reds

Red watercolor pigments are available in both transparent and opaque shades. Use this to your advantage when painting a flower.

Cadmium Reds are more opaque and can be used where light doesn't shine through the petals.

Permanent Red is more transparent and can be used to show a petal's translucence.

That is mixing beautiful transparent reds with opaque reds makes a painting visually more exciting than using opaque reds alone.

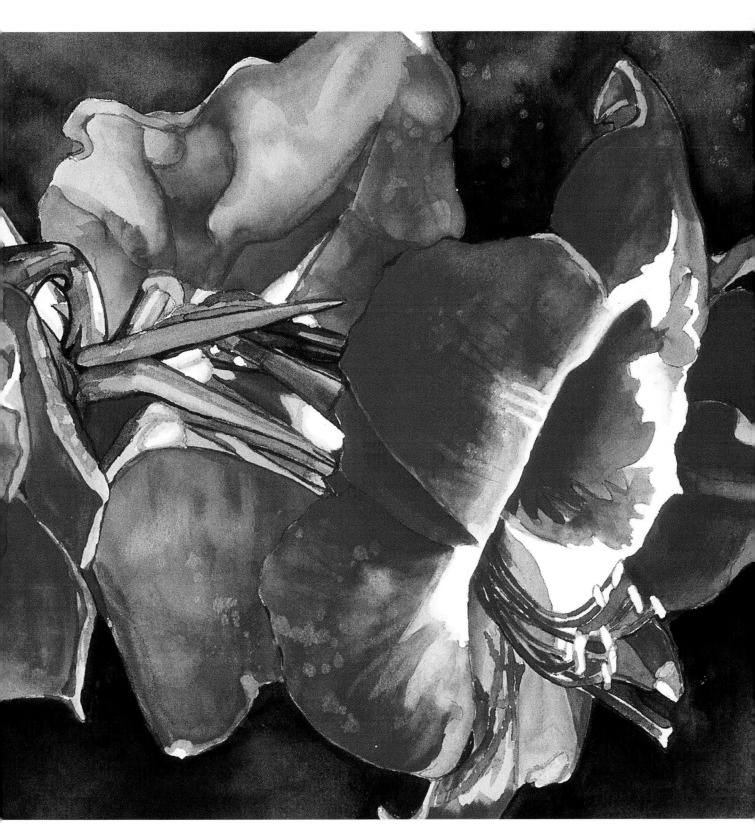

Totally Red, watercolor, 11 x 15" (28 x 38cm)

The materials you'll need for this project

Support

You will need artist-quality 140lb (300gsm) cold-pressed watercolor paper.

Pencils and paper

Use a no. 2 pencil or graphite paper to transfer the drawing onto your watercolor paper.

Brushes

- nos. 6, 8 and 12 synthetic rounds
- ¼", ½" and 1" angled brushes
- small round detail brush
- 1" or larger synthetic flat wash brush

Ink

I used opaque white ink to bring out some of the highlights and make corrections.

Masking fluids

White masking fluid helps preserve the whites in this painting. Apply it with an old brush and toothpicks. Remove it with a rubber cement pick-up.

Other materials

- Always keep a good supply of high-quality paper towels and clean water.

Watercolors

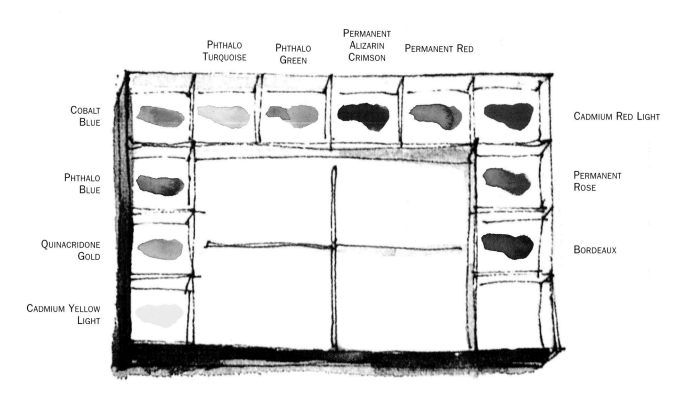

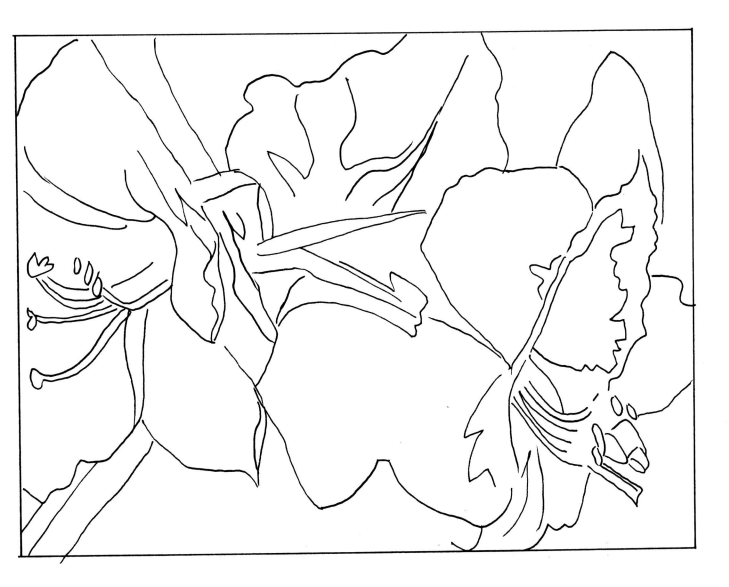

Step 1

Make a drawing

Name your painting and think of words to describe its subject matter and the way it makes you feel: dramatic, sensual, glowing.

Photocopy and enlarge the drawing to the size you want to work with. Place graphite paper between your support (the watercolor paper) and the photocopied drawing. Trace over the photocopy, lifting the graphite paper periodically to make sure you're not missing anything.

If you wish, you may also transfer the drawing without graphite paper by taping the photocopy to a window or lightbox. Tape the watercolor paper over the top, and trace.

Use a no. 2 pencil or mechanical pencil with soft lead. Any pencil marked with an H will be too hard and it will scratch the surface of your paper.

Step 2

Apply the masking fluid

Use a white masking fluid to preserve the white in your painting. Use an old or inexpensive brush to apply the masking fluid, coating it first in liquid soap. Be aware that you will not be able to reuse the brush for painting. For really tiny areas, use a toothpick to apply the masking. Don't bother to mask large white areas — you can paint around them.

Wait until the masking fluid is dry before continuing with your painting. Don't use a hair dryer to speed the process because the heat can embed the masking into the paper.

READ ME!

When you remove the masking fluid at the end of this particular painting, use a rubber cement pick-up. If you use a regular eraser to remove the fluid, red paint will rub off onto the white areas of the painting.

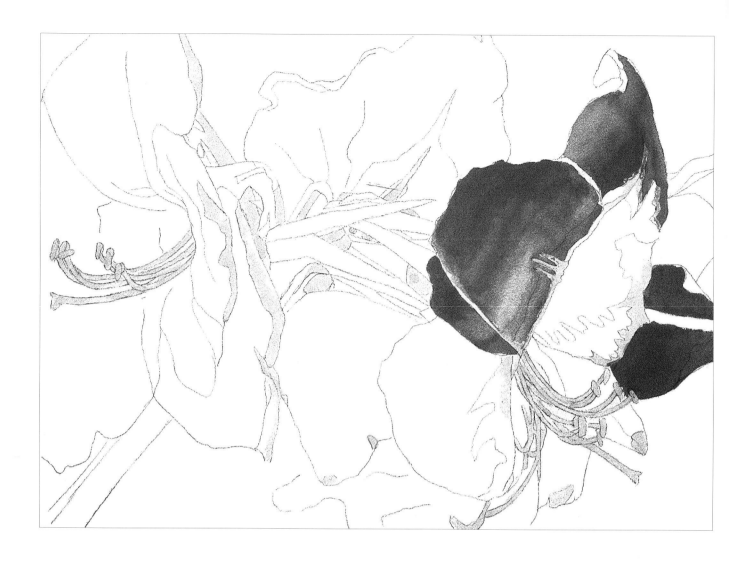

Step 3

Paint the flowers

Paint one petal at a time. The first petal is painted primarily with
a mix of Permanent Rose and Cadmium Red Light. Add water
to this mix for lighter areas in the petal and where the petal turns.
Near the highlight, make the Permanent Rose color dominant
in the mix. For the rest of the petal, make Cadmium Red Light the
dominant color. As you continue to paint the petals, vary their hues
and values. The flower on the right will be the center of interest.

Both Cadmium Red Light and Permanent Red are tomato red
colors. While Permanent Red is more transparent, both will leave
a soft, powdery residue on your watercolor paper.

Guide your brushstrokes from the center of the flower out to the
petal edge. This first application of paint will be loose. You may find
that making round, half-circle brushstrokes will make modeling the
petals much easier.

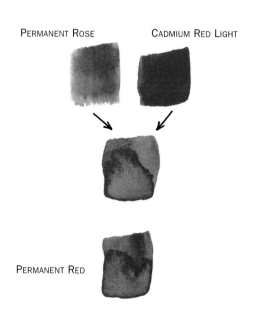

PERMANENT ROSE CADMIUM RED LIGHT

PERMANENT RED

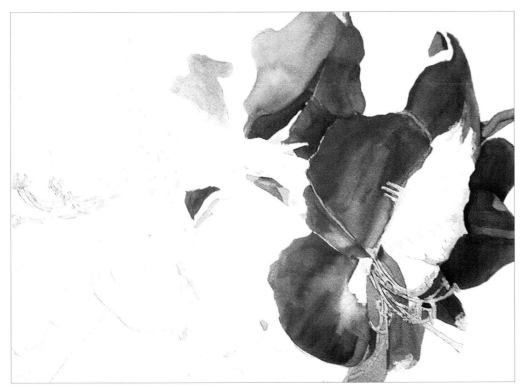

Step 4

Finish the flowers

As you progress to the center flower, of which we only see the back, add oranges into your mix. Because this flower is behind the others, it should be painted with less detail and less vibrant color. The center-of-interest flower must have the brightest color, the whitest highlights, and the most detail.

Paint the flower on the left, keeping in mind it should not be as detailed or vibrant as the flower on the right.

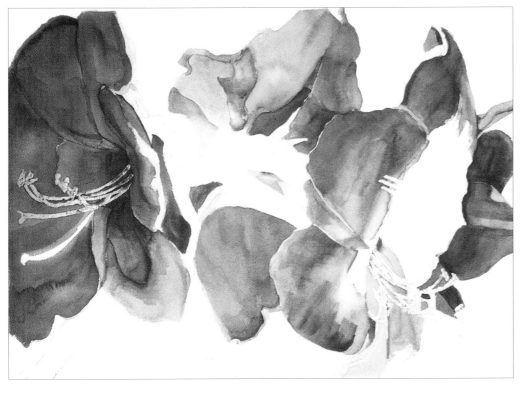

Flower color mixes

CADMIUM YELLOW LIGHT CADMIUM RED LIGHT

CADMIUM YELLOW LIGHT PERMANENT ROSE

PERMANENT ROSE

QUINACRIDONE GOLD

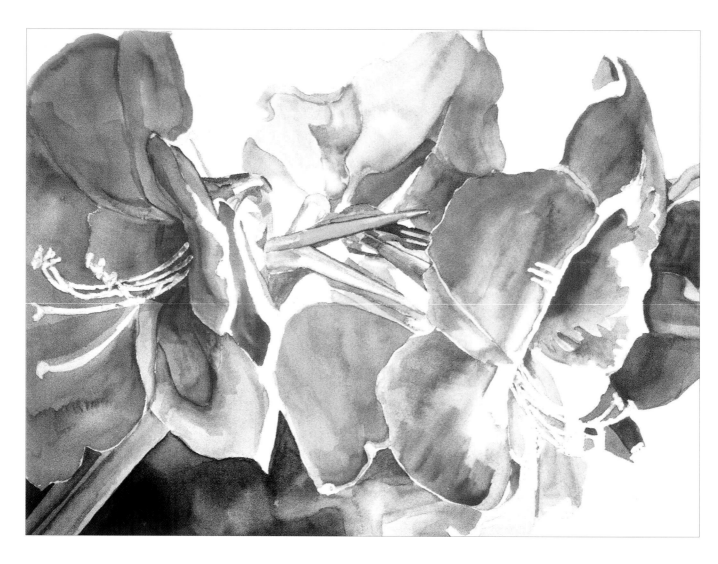

Step 5

Start painting the greens

Using a small brush, paint in the greens on the stems and flower bases. There are also several red and orange areas in the middle of the painting. Make sure to keep the center area less interesting than the flower on the right.

As you're painting the green portions of the flower structure, try to be as realistic as possible. Pay attention to how each shape begins and ends and how the flowers are connected to the stem.

Be careful to include the small dark lines and shapes that give the green structures of the flower their form. Paint the main supporting stem with both a light and dark side to create the illusion of three dimensions.

Step 6

Add color to the background

The background is segmented off into negative shapes by the boundaries of the flowers and paper. When the flower petals and stems have dried, mix a variety of dark greens, blues and reds. Use your large wash brush to wet one negative area in the background with clear water. Then drop in colors, allowing them to mix and blend on the wet paper. Keep Phthalo Green and Phthalo Blue as the dominant colors in the background, but include patches of Permanent Alizarin Crimson to harmonize the background with the flowers.

When the background is completely dry, use a rubber cement pick-up to remove the white masking fluid on the flowers and stamens. Because Cadmium and Permanent Red leave a dusty film on the surface of the paper, don't use an eraser to remove the masking fluid. The eraser could transfer red pigment into the white areas of the painting.

PHTHALO GREEN

PHTHALO BLUE

PERMANENT ALIZARIN CRIMSON

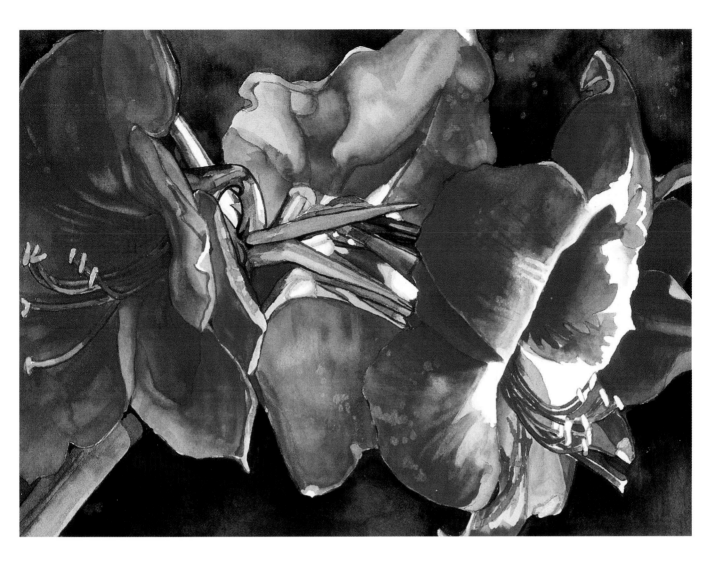

Step 7

Finish the painting

Masking fluid leaves hard edges. To soften the transition between white and red in the highlights of the flowers, use Cadmium Yellow Light to paint a thin transition area between the two colors.

Paint the stamens with your small detail brush. They should be darker and/or in shadow toward the center of the flower, and lighter toward the light.

The anthers are the bun-shaped tips of the stamens. Paint the anthers on the flower at left with Cadmium Yellow Light at the top and Quinacridone Gold at the bottom. The anthers on the focal point flower should remain white.

Soften the edges of the flower at left by dampening a brush with clear water and stroking carefully along the edges. Make sure to pass the brush over each area only once — if you repeat the stroke, it will lift color instead of softening it.

Lift paint for soft highlights by moistening a ¼" angle brush, dabbing a line at your intended highlight and then blotting with clean paper towel. Where a hard white edge meets a painted area, dab with the side of clean, damp brush. Soften some of these edges by adding Permanent Rose where the petal turns in toward the shadow.

Step back and check the values in the painting. Are the shadows deep enough? If you need to, add small dark shapes or lines to further define the edges of the petals.

Unify the background by applying a single wash of Phthalo Blue over the negative areas. Don't overwork the brush or you'll lift paint.

CADMIUM YELLOW LIGHT

QUINACRIDONE GOLD

PERMANENT ROSE

PHTHALO BLUE

PROJECT 2 PEARS

Painting with the White of Your Paper

Using the white of your paper as a design element makes the painting process fun and the final painting dramatic. The white just seems to make the painting sing. When using a wide expanse of white in your paintings, you have to keep the unpainted areas pristine — smudges and stray color would ruin the effect.

The challenges
- painting mirror-image reflections
- preserving large areas of white paper
- combining small shapes to make interesting larger shapes

What you'll learn
- how to design with the white of the paper
- how to use value to suggest form and contour and to create drama
- how to pair complementary colors to create interest
- overlapping shapes

The techniques you'll use
- preserving the white of the paper with various masking techniques
- painting wet-on-dry
- painting wet-into-wet

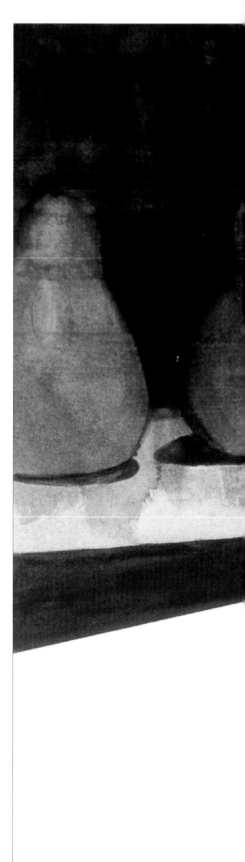

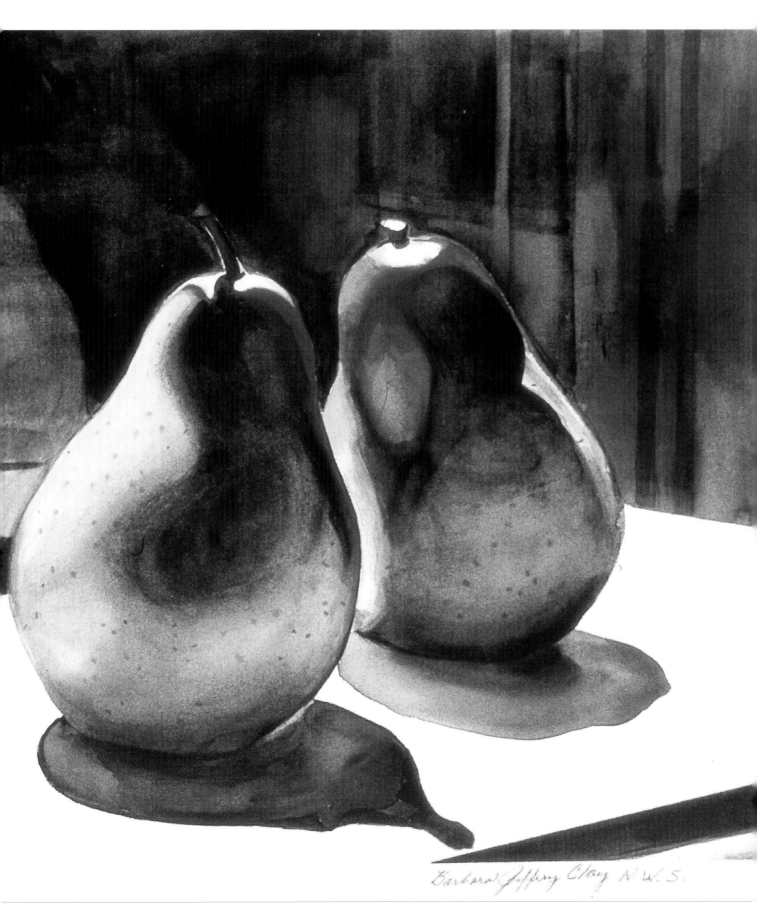

Pear-a-mount, watercolor, 14 x 18" (36 x 46cm)

The materials you'll need for this project

Support

You will need the whitest 140lb (300gsm) cold-pressed watercolor paper you can find.

Pencils and paper

Use a no. 2 pencil or graphite paper to transfer the drawing onto your watercolor paper.

Brushes

- nos. 6, 8 and 12 synthetic rounds
- ¼", ½" and 1" angled brushes
- small round detail brush

Other materials

- Always keep a good supply of high-quality paper towels and clean water.
- Masking fluid helps preserve the whites in this painting. Apply it with an old brush and toothpicks. Remove it with a rubber cement pick-up.
- Supplement your masking fluid with 1"-wide masking tape for this project.
- I used opaque white ink to bring out some of the highlights and make corrections.

Watercolors

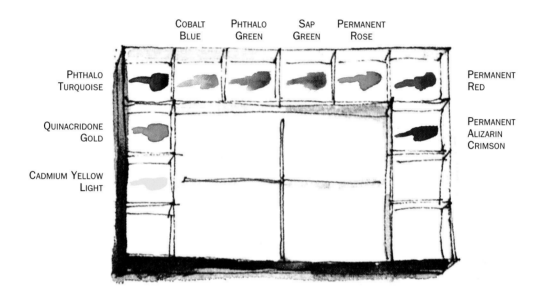

COBALT BLUE PHTHALO GREEN SAP GREEN PERMANENT ROSE

PHTHALO TURQUOISE

QUINACRIDONE GOLD

CADMIUM YELLOW LIGHT

PERMANENT RED

PERMANENT ALIZARIN CRIMSON

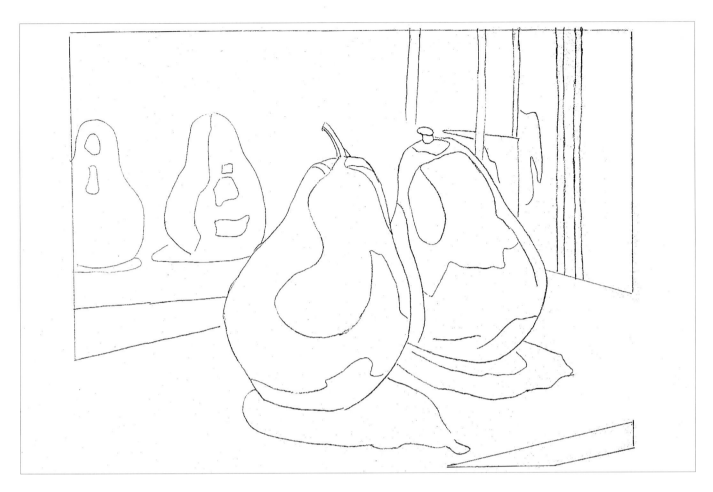

Step 1

Get ready to paint

Name your painting and think of words to describe its subject matter and the way it makes you feel: organic, sculptural, contrast, richness.

Photocopy and enlarge the drawing to the size you wish to work with. Place graphite paper between your support and the photocopied drawing. Trace over the photocopy, lifting the graphite paper periodically to make sure you're not missing anything.

If you wish, you may also transfer the drawing without graphite paper by taping the photocopy to a window or lightbox. Tape the watercolor paper over the top, and trace.

Use a no.2 pencil or mechanical pencil with soft lead. Any pencil marked with an H will be too hard and it will scratch the surface of your paper. Be careful as you transfer the drawing — too much erasing on watercolor paper can cause the paint to blotch later.

Step 2

Apply the masking

Apply masking tape along the straight lines that border white areas in your drawing and along the bottom of the pears in the areas to remain pure white. Cut the tape with scissors, not a craft knife — a craft knife would score your paper and then fill with paint later, creating a dark mark. When the tape is in place, burnish it to the paper with your fingers or a smooth, blunt object. Paint will seep under any tape edge that is not firmly sealed to the paper.

Apply masking fluid to the highlights on the pears. You can use an applicator pen or toothpicks.

Step 3

Paint the dark background

Wet the background area with clear water and, beginning at an edge, drop in varying values of Phthalo Turquoise, Cobalt Blue, Permanent Alizarin Crimson, Permanent Red, Phthalo Green and Sap Green. As you paint around the pears and their reflections, place red colors closest to the pears. Because the pears are green, they will stand out against a background of their complementary color, red. Paint cleanly around the pears to create the hard edge appropriate for the center of interest.

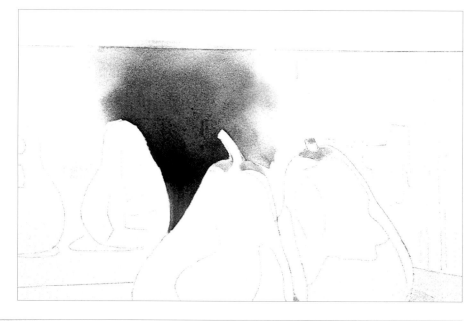

This sample was painted wet-into-wet, allowing the colors to mix and blend in interesting ways on the paper.

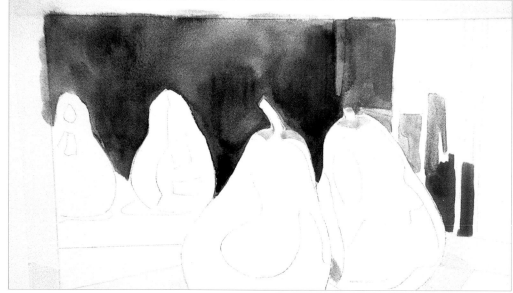

This sample was painted wet-on-dry. It is darker and the colors haven't mixed as loosely.

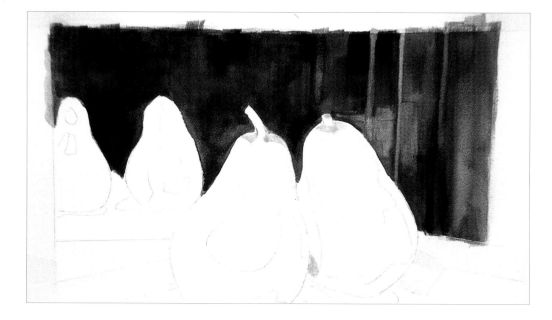

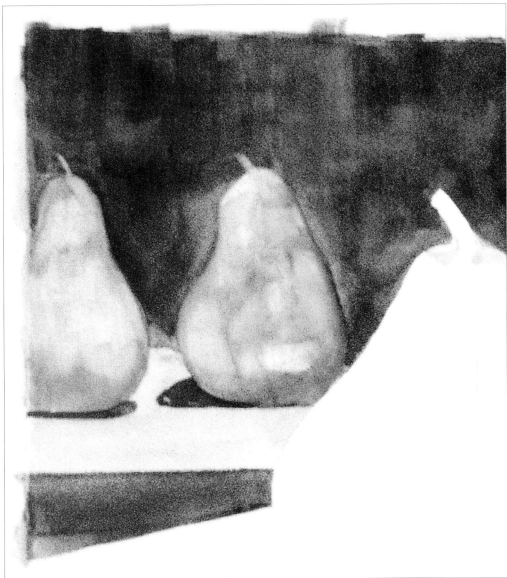

Step 4

Paint the reflections

After the background is completely dry, start painting the reflections of the pears in the window. Keep in mind that, in order to make these pears recede into the background, you must paint them with softer edges, less vivid colors and less detail than you would the pears in the foreground.

Use a variety of color mixes: Phthalo Turquoise and Quinacridone Gold mix up to a wonderful transparent color, while Cadmium Yellow Light and Cobalt Blue together are more opaque. Make your brushstrokes in the direction of the form of each pear. This will reinforce the pear's shape.

When the pears are completely dry, paint the shadows they cast on the table with a mix of Permanent Alizarin Crimson and Phthalo Green.

Once the shadows are dry, proceed to the reflected tabletop. Mix a soft blue from Cobalt Blue and Permanent Rose, then dilute it to make it even softer.

To push the reflections further back, wash over them with horizontal strokes of a diluted gray after they are completely dry.

TIP

Good composition favors odd numbers of elements. Although we see four pears in this painting, the two foreground pears overlap, creating one larger shape. We are left with three dominant shapes, a good number for an interesting design.

Pear colors

CADMIUM YELLOW LIGHT + PHTHALO TURQUOISE

CADMIUM YELLOW LIGHT + COBALT BLUE

CADMIUM YELLOW LIGHT + PHTHALO GREEN

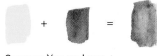

CADMIUM YELLOW LIGHT + SAP GREEN

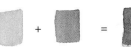

QUINACRIDONE GOLD + PHTHALO TURQUOISE

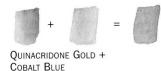

QUINACRIDONE GOLD + COBALT BLUE

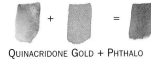

QUINACRIDONE GOLD + PHTHALO GREEN

QUINACRIDONE GOLD + SAP GREEN

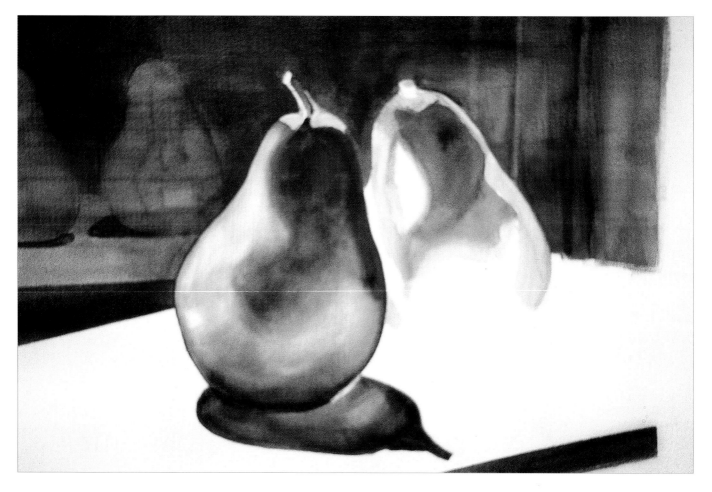

Step 5

Paint the foreground pears

The two foreground pears are the center of interest. Start by painting the pear closest to the viewer using a mix of Quinacridone Gold and Cadmium Yellow Light for the lighter areas and mixes of Sap Green and Phthalo Green with Permanent Alizarin Crimson for the darker areas. The dark peanut or figure-8 shape on the pear is a shadow, and its shape helps the viewer see the contour of the pear. Leave a little area of white on the bottom left of the pear for a highlight.

Refine the pear by glazing with various greens, yellows and reds in the light areas. For the greens, use Sap Green mixed with Quinacridone Gold and/or Cadmium Yellow Light. For red tones, use Permanent Alizarin Crimson and Permanent Red.

When the pear is completely dry, remove the tape from the lower edge. Clean up the taped edge by glazing in a line along the bottom edge of the pear.

Finish the pear by painting its shadow. Paint the outline of the shadow with a dark mix of Phthalo Green and Permanent Alizarin Crimson. Then apply water inside the outline and drop in Quinacridone Gold, Cobalt Blue and Permanent Rose wet-into-wet. Paint the darkest portion of the shadow, directly under the pear, with the Phthalo Green and Permanent Alizarin Crimson mix.

READ ME!

Practice! Get out some scraps of watercolor paper and experiment with pears. Try different brushstrokes and color choices. Once you've developed your techniques, move on to the pears in this painting.

CADMIUM YELLOW LIGHT

QUINACRIDONE GOLD

QUINACRIDONE GOLD + PHTHALO TURQUOISE

PERMANENT ALIZARIN CRIMSON + SAP GREEN

PHTHALO GREEN + PERMANENT ALIZARIN CRIMSON

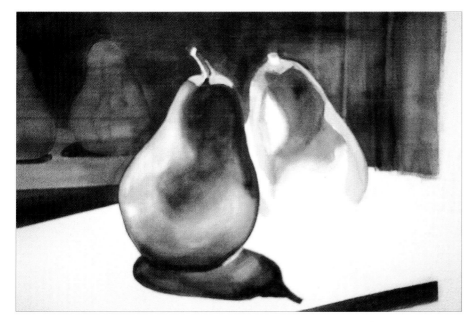

Step 6

Finalize the background

When the paper is once again completely dry, create a somewhat dark mix of Permanent Alizarin Crimson and Phthalo Turquoise. Use your 1" wash brush to paint horizontal strokes of this color over the background. This will push the reflections further back by darkening the color and blurring the edges.

Be careful! Take the brush over each area just one time. A second stroke could cause the paint underneath to lift and ruin the painting.

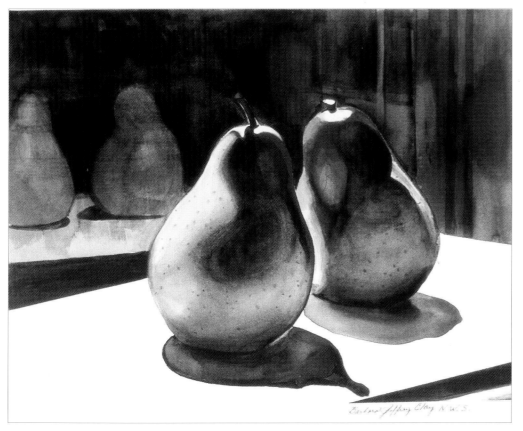

Step 7

Finish the foreground pears

Paint the second pear in the foreground just as you did the first, following the form of the pear with your brushstrokes. After painting the pear's shadow, let the paper dry completely. Remove the masking tape directly under the pear and clean up the line as you did with the first pear.

Very carefully, remove each piece of masking tape one-by-one, slowly and gently. Don't let overlapping pieces pull off together.

Protecting your watercolor paper with paper towels, add tiny dots of red paint to the pears with a detail brush.

Finally, remove the masking fluid and soften the edges of the paint with a clean, damp brush.

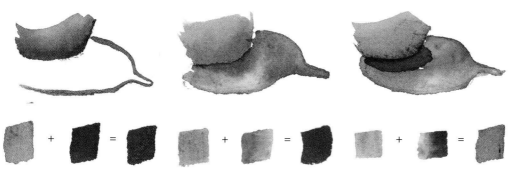

PHTHALO GREEN + PERMANENT ALIZARIN CRIMSON

QUINACRIDONE GOLD + COBALT BLUE

PHTHALO GREEN + PERMANENT ALIZARIN CRIMSON

TIP

To keep the white paper as clean as possible, place a paper towel near the pears as you paint. Spatters and spills will hit the paper towel instead of your paper.

PROJECT 3 AZALEA BOUQUET

Painting Softness Wet-into-Wet

I wanted this painting of a bouquet of azaleas to express the gentleness of spring, so I made the composition simple, the colors harmonious and the texture very soft and muted.

The bouquet is set in an unassuming pitcher against a simple drapery background. The simplicity surrounding the flowers draws the viewer's attention to the azaleas while contributing to the overall softness of the painting.

The colors in the painting are especially harmonious because they are based on an analogous color scheme: three colors next to each other on the color wheel. The dominance of red and its analogous colors of orange and purple is restful to the eye.

The texture of the painting is very soft because it is painted primarily with wet-into-wet techniques. Painting wet-into-wet creates very soft edges, and because more water is used with this technique, the colors will be more gentle.

The challenges

- creating soft textures by painting wet-into-wet
- using an analogous color scheme
- creating interest with values of analogous colors

What you'll learn

- how to combine small shapes to form interesting large shapes
- how to paint a background that supports the subject in form and color without detracting from it
- how to guide the viewer's eye by linking analogous colors
- how to manipulate color temperatures to create interest

The techniques you'll use

- painting wet-into-wet

Analogous colors

An analogous color scheme uses three colors next to each other on the color wheel. This painting uses red as the dominant color along with its analogous colors, purple and orange.

Working with an analogous color scheme

Analogous colors are next to each other on the color wheel. This applies to families of color as well. Pinks and roses are variations of red, and therefore are analogous to oranges and purples. Using analogous colors promotes a feeling of harmony in the painting. Keep your painting interesting as well by using variations of your analogous colors: warm and cool, pale and deep.

YELLOW ORANGE

GREEN RED

BLUE PURPLE

Azalea Bouquet, watercolor, 24 x 20" (61 x 51cm)

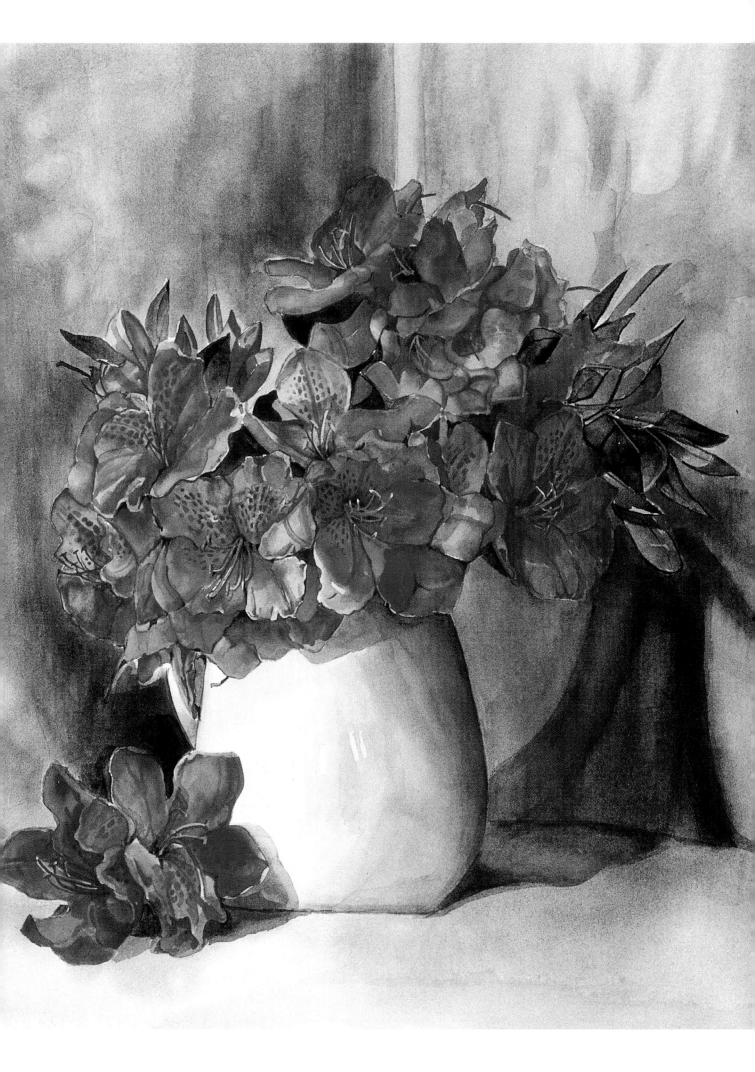

The materials you'll need for this project

Support

You will need 140lb (300gsm) cold-pressed artist-quality watercolor paper.

Pencils and tracing paper

Use a no. 2 pencil or graphite paper to transfer the drawing onto your watercolor paper.

Brushes

- nos. 6, 8 and 12 synthetic rounds
- ¼", ½" and 1" angled brushes
- small round detail brush
- 1" or larger synthetic flat

Other materials

- Always keep a good supply of high-quality paper towels and clean water.
- You will need a clean, non-staining, stiff board to support your watercolor paper.
- A large sponge makes wetting your paper prior to painting much easier.
- I used opaque white ink on the petals of some of the flowers.

Watercolors

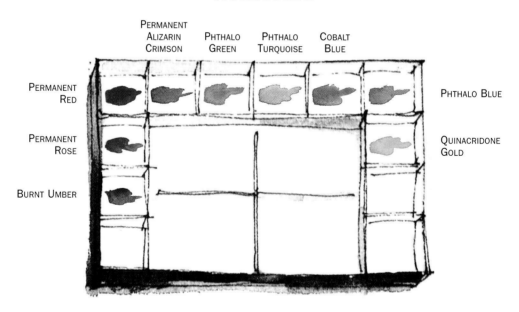

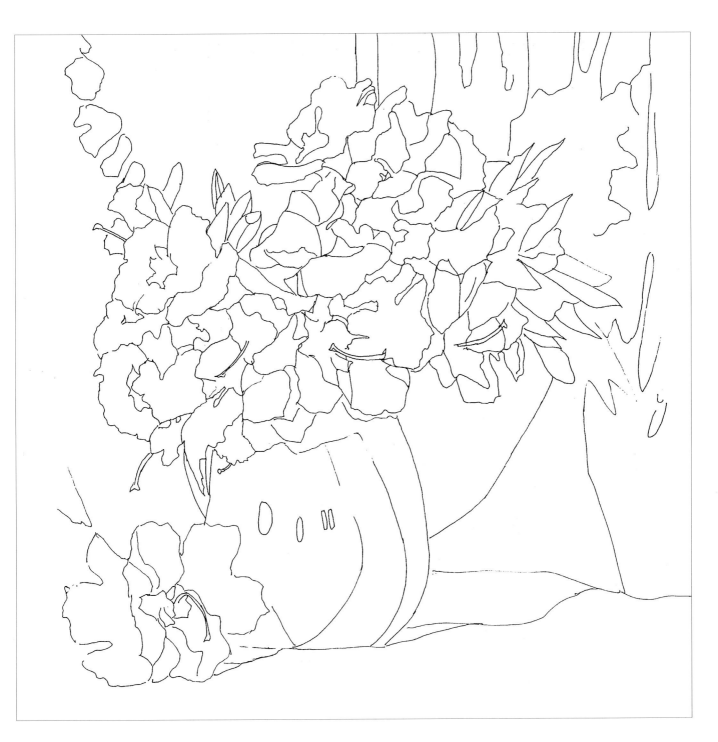

Step 1

Get ready to paint

Name your painting and think of words to describe its subject matter and the way it makes you feel: Spring, soft, petals, gentle.

Photocopy and enlarge the drawing to the size you wish to work with. Place graphite paper between your support and the photocopied drawing. Trace over the photocopy, lifting the graphite paper periodically to make sure you're not missing anything.

Use a no. 2 pencil or mechanical pencil with soft lead. Any pencil marked with an H will be too hard and it will scratch the surface of your paper. Be careful as you transfer the drawing — too much erasing on watercolor paper can cause the paint to blotch later.

Step 2

Paint the background wet-into-wet

Working on a flat surface, place your watercolor paper on your support board, then use a wet sponge to wet the entire surface of the paper. Flip the paper over and wet the other side in the same way. Air bubbles may form as you go. Keep flipping and wetting the paper until you see no more bubbles in the paper's surface. At this point, the wet paper will stick to the board, so make sure you finish with the drawing side up.

Using variations of the color mixes shown on this page, apply paint to the wet paper, allowing colors to mix, soften and bleed. A 1" or larger wash brush or flat is useful for this step. If you keep your paper flat, the flow of color will be more gentle. Remember that the colors will lighten when they dry.

Although you should leave white paper where there will be flowers, do not be concerned if some of your paint bleeds into these areas.

Defining shapes in your composition

Notice that the white area that will contain the flowers is one big shape. When composing the painting, the biggest shape will have the most impact, so be sure to make it visually interesting. That big shape will be divided into the several smaller shapes of individual flowers, which in turn will be divided into the even smaller shapes of individual petals. To define these smaller shapes within the big shape, we must give them form using value changes. Each flower needs to have light, medium and dark values to give the illusion of dimensionality.

Step 3

Paint the vase

To give the vase form and structure, we need to suggest contour with value — highlights and shadow. To determine where the highlights and shadows should go, we need to know where the light is coming from. In this case, the light is coming from the left side, so the darkest area of the vase will be on the right. Make a blue-dominant, dark mix of Cobalt Blue and Permanent Rose and apply it in a vertical stripe on the right side of the vase. Add a little Phthalo Blue to the mix and lighten it a bit, then apply a second vertical stripe to the left of the first one. because you're painting wet-into-wet, the colors will blend at the edges. Finally, make a Cobalt Blue and Permanent Rose mix in which the Rose is dominant and paint the third vertical stripe on the vase.

Paint the top of the vase with an orange made from Permanent Rose and Quinacridone Gold. Leave the highlights and the left side of the vase white. I didn't bother to mask out the whites, because they were big enough to paint around.

The vase casts a shadow onto the table and drapery. Paint this shadow with Phthalo Green and purples made from Permanent Rose and Cobalt Blue. Add some Burnt Umber. As you apply the paint, stroke in the direction of the surface: horizontal for the table and vertical for the drapery.

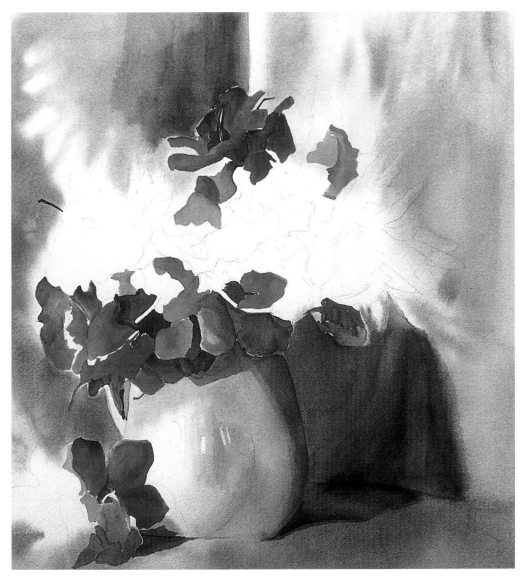

TIP

Closely examine the flowers you wish to paint. How are the petals arranged? Are they all the same, or are some different? Which way do the stamens turn? How are the leaves shaped and how big are they relative to the flowers? How do the leaves and flowers join the stem?

Flower colors

PERMANENT ALIZARIN CRIMSON + WATER

PERMANENT RED + WATER

PERMANENT ROSE + WATER

PERMANENT ALIZARIN CRIMSON + PERMANENT RED

PERMANENT ROSE + PERMANENT RED

PERMANENT ROSE + PERMANENT ALIZARIN CRIMSON

PERMANENT ALIZARIN CRIMSON + QUINACRIDONE GOLD

PERMANENT ROSE + QUINACRIDONE GOLD

Step 4

Refine the vase and background and start the flowers

Make sure your painting is dry before beginning this step. To check, touch the surface with the back of your hand. If it's cold to the touch, it's still a little damp. If you add paint before the painting is dry, you may accidentally create blossoms — water spots that are difficult to remove.

Refine the background by glazing over the first wash of paint. Glazing simply means to add a layer of wet paint over a dry layer. Be careful when glazing not to overwork the brush — you can accidentally lift color this way. As you glaze over the background, deepen values as necessary.

When the background is dry, reinforce the form of the vase by glazing over the darkest value on the right side with a hard edge. You will also need a hard edge where the vase meets the table. These sharp lines will help separate the vase from the background. Deepen the vase's shadow to help further distinguish it from the background and to anchor it firmly on the table.

Mix a number of reds as shown in the color swatches on this page. Using angle brushes, paint each petal individually, varying color from one petal to the next. Remember to use a light, medium and dark value on each petal to give it form. Start by painting each flower with a flat application of a darker value. While the paint is still wet, add a slightly darker value near the base. This will blend to create subtle form. Lift paint from the petal where it is hit by light using a thirsty brush — a clean, damp brush that will absorb wet paint from the paper when touched to the surface. Some petals will be completely in shadow, so paint these darker overall.

The angle brushes work especially well when painting the flower petals. They allow the color to soften at the edge of the brushstroke. Use the longer end of the brush along the drawing line and the short end to blend colors.

Step 5

Finish the flowers and paint the leaves

When the flowers are dry, paint a pale wash of Phthalo Blue over those in the shadow to the right of the vase. Many flowers will contain shadows cast by the other flowers in the vase. Paint these now as well.

Paint the leaves in a variety of greens. Azalea leaves are long and pointed. Keep them the right shape and size so they will be believable.

Further refine the background by establishing form. Warm colors (pink) next to cool colors (blue) are visually interesting.

Leaf colors

COBALT BLUE +
QUINACRIDONE GOLD

PHTHALO BLUE +
QUINACRIDONE GOLD

PHTHALO TURQUOISE +
QUINACRIDONE GOLD

PHTHALO GREEN +
QUINACRIDONE GOLD

PHTHALO GREEN +
PERMANENT ALIZARIN CRIMSON

PHTHALO GREEN +
PERMANENT ROSE

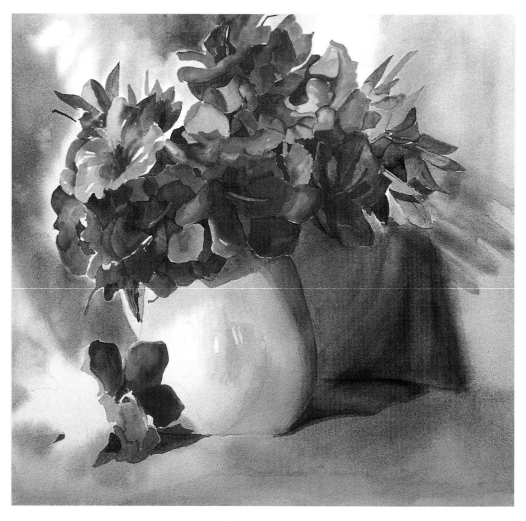

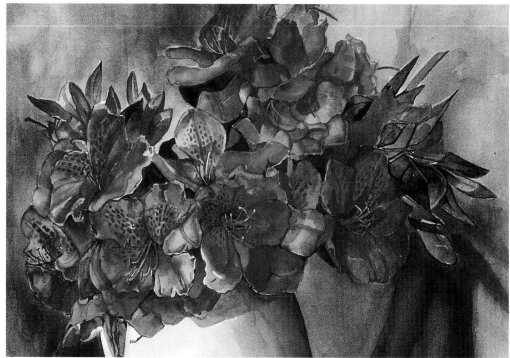

Finished flowers

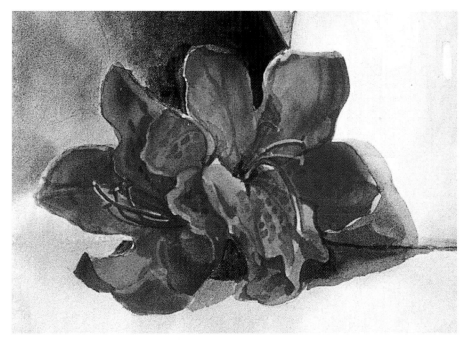

Step 6

Paint the tabletop flowers

Paint the flowers lying to the side of the vase one at a time, starting with Permanent Rose. Use a mix of Permanent Rose and Phthalo Blue for the shadow areas. With a small round brush, paint in the dots that appear on some of the petals and the indentations and folds in all the petals. Let the first flower dry before painting the second. When both flowers are dry, paint the center stamens, which curve up from the center of each flower. The stamens have small bun shapes at their tips. When the stamens have dried, add detail darks.

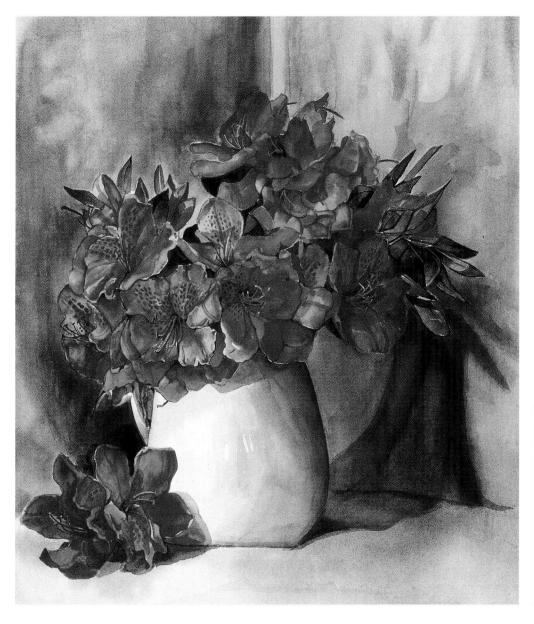

Step 7

Finish the background

Step back and evaluate the values in your painting. At this stage, you may need to darken the background on each side of the vase to make the vase come forward. Look for areas that need additional dark values or more color. When you've made your adjustments, let the painting dry before critiquing it one more time.

TIP

Because watercolor is so transparent, brilliance of color comes from light reflecting from the white paper back through the paint. Every time you add another layer of paint, you lose some of this reflection, and therefore transparency, so be careful to add only as many layers of paint as you absolutely need.

PROJECT 4 CORN

Painting Colorful Darks

To the untrained eye, all areas of shadow or deep value seem to be dark shades of gray or brown. But if you pay close attention, darkness contains all sorts of color. In this project, you will learn how to paint colorful shadows that will enrich your painting and highlight your subject. You will choose and mix interesting dark-value colors for your subject as well.

The challenges

- creating interest by painting rich, colorful dark values
- choosing and mixing deep values
- combining light and dark values in a pleasing composition

What you'll learn

- how to include color complements in shadows to highlight the subject
- how to use dark values to make your light values glow
- how to place light and dark values to create interest

The techniques you'll use

- masking to preserve whites
- wet-into-wet washes
- color mixing

Making a color chart

I made the chart of color mixes below by first painting a set of colors across the top of the chart, then painting the same set of colors down the left side. I combined two colors at a time, painting a swatch of the resulting color where the two parent colors intersected. Note that I didn't duplicate colors — the swatch for 1 down and 2 across would have been the same as for 2 down and 1 across.

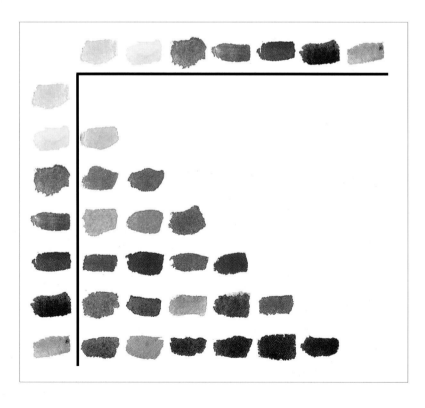

Ancient Harvest, watercolor, 14 x 14" (36 x 36cm)

Barbara Jeffery Clay, NWS

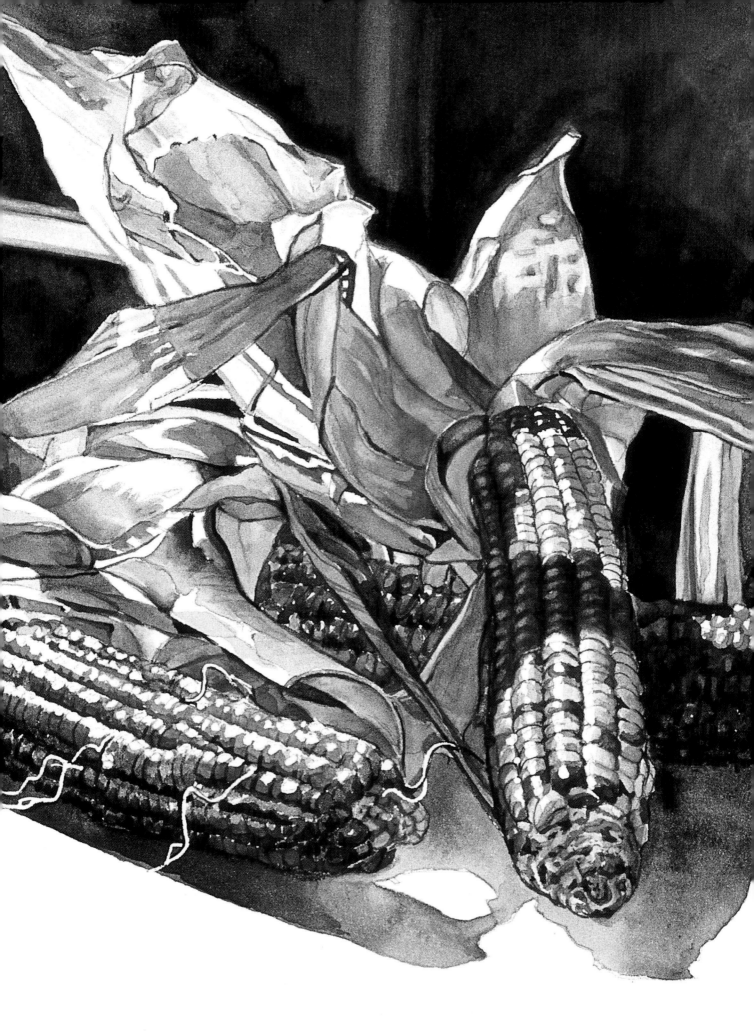

The materials you'll need for this project

Support

You will need artist-quality 140lb (300gsm) cold-pressed watercolor paper.

Brushes

- nos. 6, 8 and 12 synthetic rounds
- ¼" and ½" angle brushes
- small round detail brush

Pencils and paper

Use a no. 2 pencil or graphite paper to transfer the drawing onto your watercolor paper.

Other materials

- Always keep a good supply of high-quality paper towels and clean water.
- White masking fluid helps preserve the whites in this painting. Apply it with an old brush and toothpicks. Remove it with a rubber cement pick-up.

Watercolors

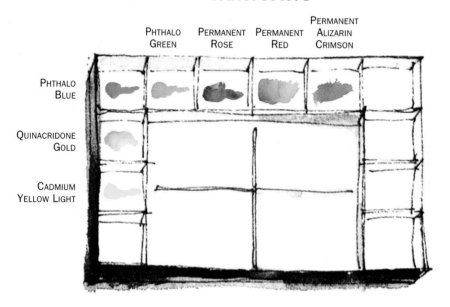

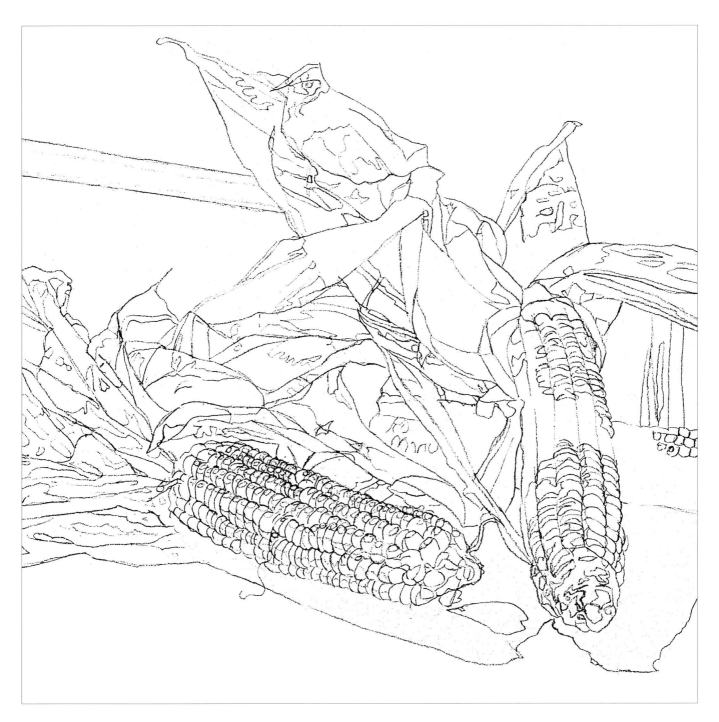

Step 1

Get ready to paint

Name your painting and think of words to describe its subject matter and the way it makes you feel: autumn colors, golden fields, richness.

Photocopy and enlarge the drawing to the size you wish to work with. Place graphite paper between your support and the photocopied drawing. Trace over the photocopy, lifting the graphite paper periodically to make sure you're not missing anything.

If you wish, you may also transfer the drawing without graphite paper by taping the photocopy to a window or lightbox. Tape the watercolor paper over the top, and trace.

Use a no. 2 pencil or mechanical pencil with soft lead. Any pencil marked with an H will be too hard and it will scratch the surface of your paper. Be careful as you transfer the drawing — too much erasing on watercolor paper can cause the paint to blotch later.

Step 2

Apply the masking

Use a white masking fluid to help remind you that the masked areas will be white in your painting. If the masking fluid were dark or a color, it would be difficult to assess value relationships while the masking fluid was in place. White masking liquid helps you to more accurately see values as you are painting.

Use an old or inexpensive brush to apply the masking fluid, coating it first in liquid soap. Be aware that you will not be able to reuse the brush for painting. For really tiny areas, use a toothpick to apply the masking. Don't bother to mask large white areas — you can paint around them.

Wait until the masking fluid is dry before continuing with your painting. Don't use a hair dryer to speed the process because the heat can embed the masking into the paper.

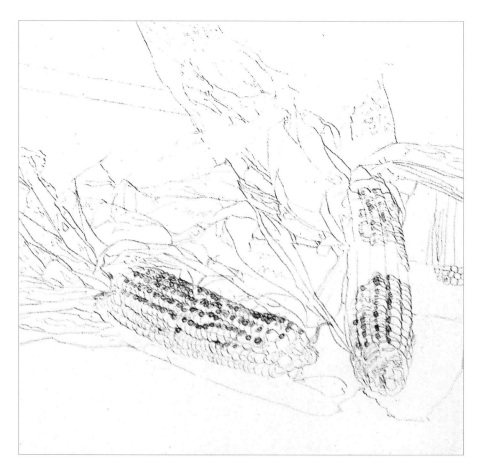

Step 3

Paint the background

Choose an area of the background that is small enough that you can completely cover it with paint before the paint starts to dry. Wet this area with clear water. While the paper is still wet, use a round brush to drop in dark values of Phthalo Green, Phthalo Blue, Permanent Rose and Permanent Alizarin Crimson. The colors will mix and blend on the paper, creating soft edges where one color meets the next. Soft edges help the background recede — crisp edges seem to come forward.

Continue to paint the background in this way, section by section.

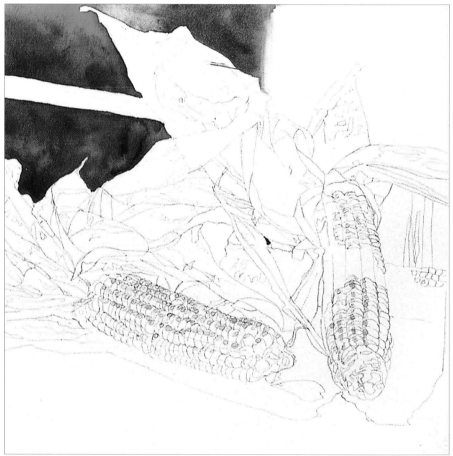

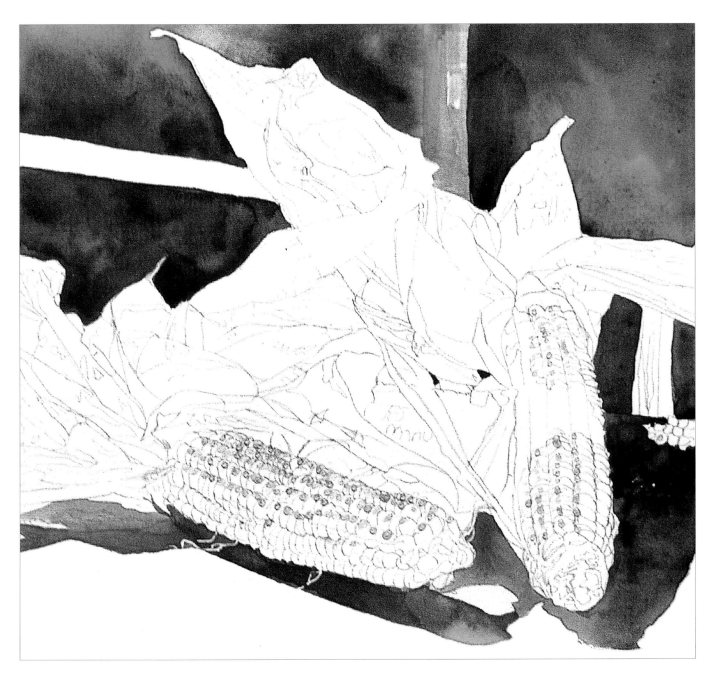

Step 4

Paint the shadows

Next, paint the shadows under the corn using the same technique as for the background. Notice that the edges of the shadows are very clean, but the color within the shadows is very loose. I painted the tips of the shadows with slightly lighter values of the shadow colors to add interest.

Keep a piece of paper towel over the parts of the paper that should remain white. If you make a mistake, blot up pigment with clean paper towel or a brush dampened with clear water.

PHTHALO GREEN +
QUINACRIDONE GOLD

PERMANENT ROSE +
QUINACRIDONE GOLD

PERMANENT ROSE +
PHTHALO BLUE

PERMANENT ALIZARIN
CRIMSON + PHTHALO
GREEN — DARK

PERMANENT ALIZARIN
CRIMSON + PHTHALO
GREEN

PERMANENT ALIZARIN
CRIMSON + PHTHALO
BLUE

Step 5

Paint the corn kernels

Masking fluid will protect the highlights on the corn while you are painting. I have removed it for this photo so you can see the highlights, but make sure you wait to remove your masking fluid until the very end of the painting process.

To keep each kernel of corn separate and crisp, paint the corn wet-on-dry. This means you won't dampen the paper with water before you start painting. Paint each kernel of corn separately, giving it dimension by adding darker color at the bottom. Notice that the kernels in light are much brighter and more colorful than the kernels in shadow, but the shadowed kernels are still very colorful. Paint the corn in the background with less detail and duller colors.

Use curved strokes to paint the corn. In general, your brushstrokes should follow the form you are painting. If you are painting something tall and skinny, your brushstrokes should be long and thin. If you are painting something wide and flat, your brushstrokes should be smooth and straight.

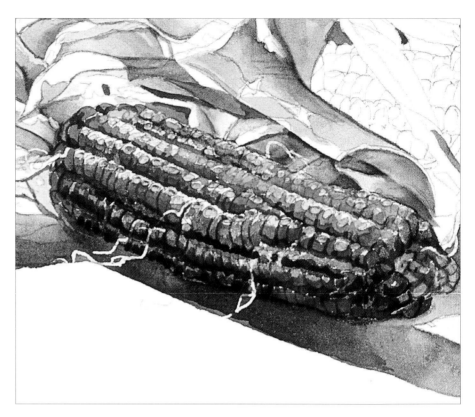

Step 6

Paint the corn husks

You don't want the corn husks to detract from your center of interest — the corn itself — so add more water to the pigment so they will be lighter and more muted in color. Painting wet-on-dry, fill in the husks with pale yellows and oranges. Allow your brushstrokes to follow the husks from base to tip. Leave some of the white of the paper for highlights, and add in some darker details.

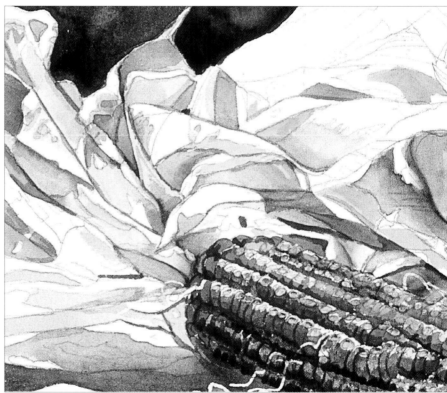

> **TIP**
>
> Keep your water fresh and clean. Dirty water on the brush will gray down your colors.

Mixing neutral colors

You can mix a neutral color by combining three primary colors. The particular pigments you choose for your primary colors will affect the value and temperature of the resulting neutral.

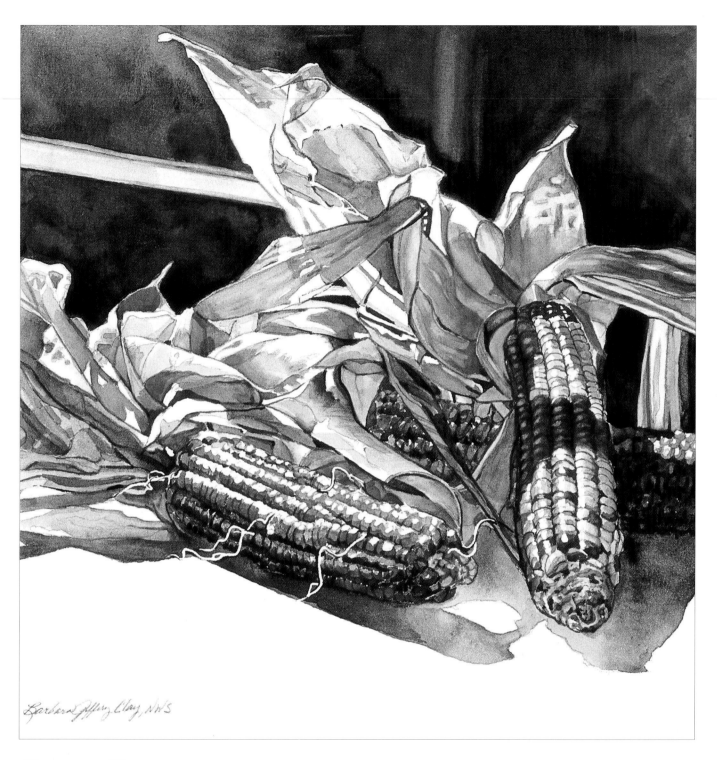

Step 7

Finish the painting

Re-examine the corn and deepen the shadows as needed. Give dimension to the white rail running behind the corn by painting it with soft blues and grays mixed from Phthalo Blue, Quinacridone Gold and Permanent Rose. Paint the white object at the right of the painting with the same colors.

When the paper is completely dry and you've made all your finishing touches, remove the masking fluid. Soften the exposed edges with clear water as needed.

PROJECT 5 WINTER

Painting a Winter Scene

Out west in Santa Fe and Taos, the adobe is the most common type of structure. The colors of adobe walls vary with the rays of the sun, ranging from flesh tones to warm golden oranges. Although very simple, adobes are unique in line and form. The walls and fences are made of native mud and grasses, and the buildings are rarely square. They can be crooked, rounded and soft in appearance. Adobe fences, also called coyote fences, are walls with an arched gate. The colors and forms of adobe buildings capture like nothing else the culture and ambience of the American Southwest.

Typical paintings of the Southwest are drenched in dry sunlight. But Taos, New Mexico, gets cold and snowy in the winter. The contrast of the cold snow against the warm adobe structure creates interest in this painting.

For this painting, I tried something different. Instead of watercolor paper, I used something new in the watercolor market: watercolor canvas mounted to a panel.

The challenges
- painting the colors and forms of white snow
- capturing the ambiance of an area
- using a building for the center of interest

What you'll learn
- how to render a structure that has curves and soft forms
- how to place color in the white, snowy areas
- how to paint snow on pine trees

The techniques you'll use
- creating depth using color temperature
- creating depth using variations in detail
- pale washes
- applying gouache for added texture

Color dominance

Throughout this project, I'll be referring to color mixes by the specific pigments used and by the dominant color. For instance, the sky calls for a blue-dominant mix of Phthalo Blue and Permanent Red. This means that the mix should favor the color blue.

PHTHALO TURQUOISE + PERMANENT ROSE
BLUE-DOMINANT MIX

PHTHALO TURQUOISE + PERMANENT ROSE
RED-DOMINANT MIX

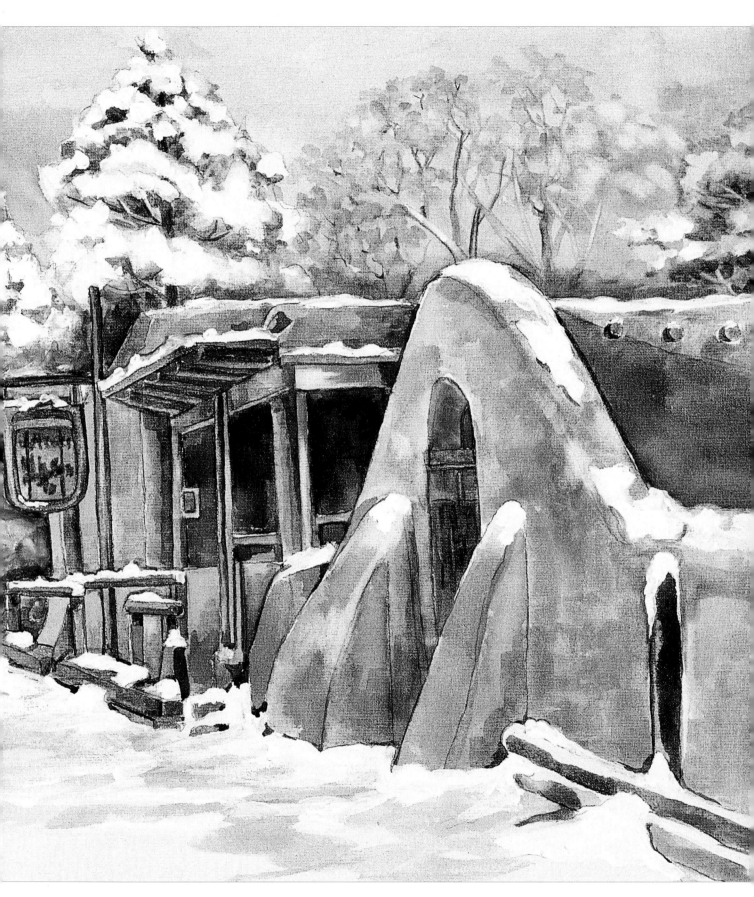

Taos Winter, watercolor, 11 x 14" (28 x 36cm)

The materials you'll need for this project

Support

For this painting, you may want to try watercolor canvas mounted on panel.

Pencils and paper

Use a no. 2 pencil or graphite paper to transfer the drawing onto your watercolor paper.

Brushes

- nos. 6, 8 and 12 rounds
- ¼", ½" and 1" angled brushes
- small round detail brush
- small rigger

Other materials

- Always keep a good supply of high-quality paper towels and clean water.
- Opaque white gouache adds texture to the snow in this painting
- Opaque white ink can also be used to make corrections and add highlights.

Watercolors

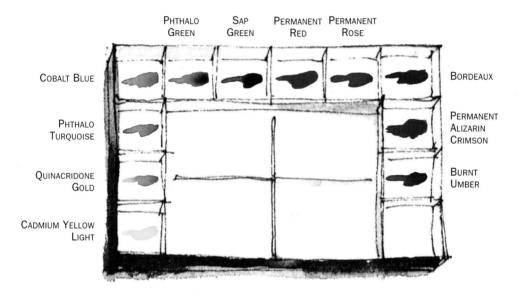

Color swatches

I created several adobe colors by mixing each of my reds with each of my yellows. I find it helpful to make a chart like this of greens mixed from blues and yellows as well. It's much easier to find the right color combinations when you have a color mix chart in front of you.

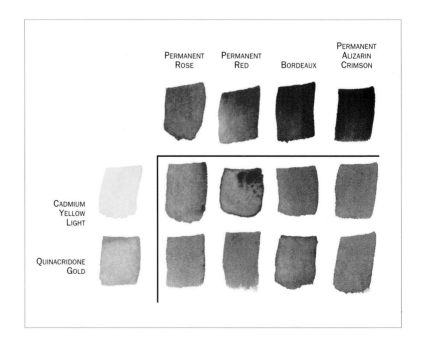

48

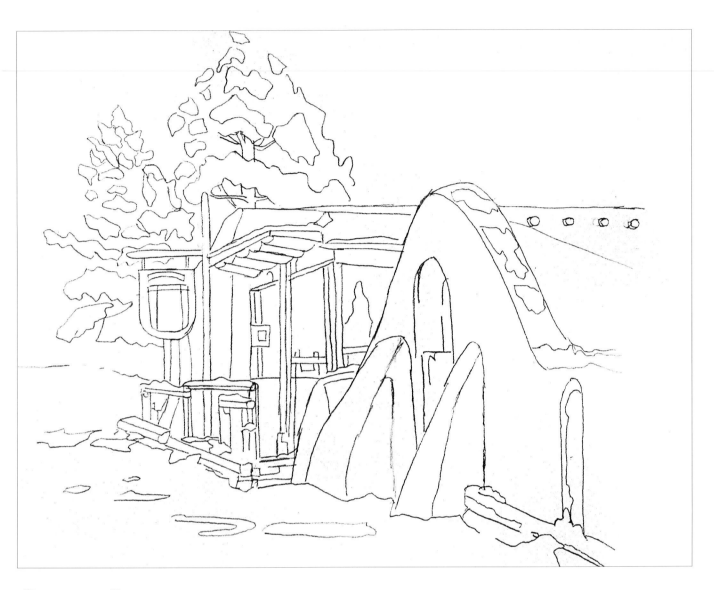

Step 1

Get ready to paint

Name your painting and think of words to describe its subject matter and the way it makes you feel: adobe, snow, color, Southwest.

Photocopy and enlarge the drawing to the size you wish to work with. Place graphite paper between your support and the photocopied drawing. Trace over the photocopy, lifting the graphite paper periodically to make sure you're not missing anything.

If you wish, you may also transfer the drawing without graphite paper by taping the photocopy to a window or lightbox. Tape the watercolor paper over the top, and trace.

Use a no. 2 pencil or mechanical pencil with soft lead. Any pencil marked with an H will be too hard and it will scratch the surface of your paper. Be careful as you transfer the drawing — too much erasing on watercolor paper can cause the paint to blotch later.

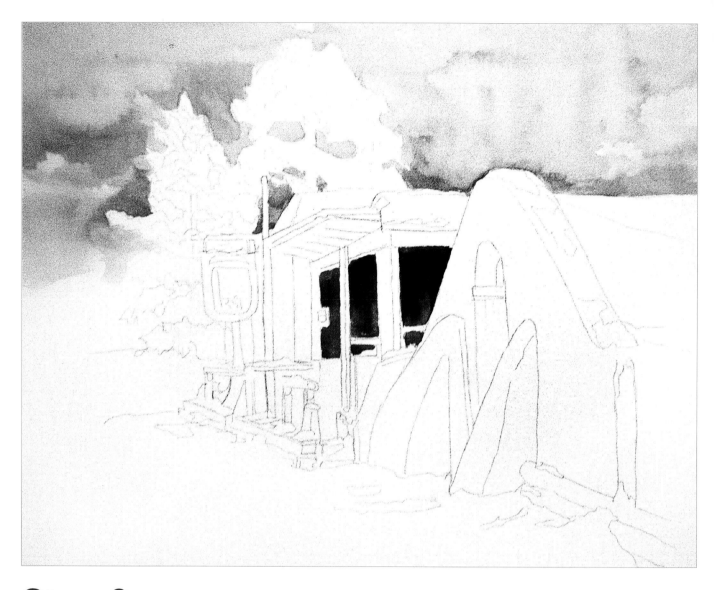

Step 2

Paint the sky and windows

Paint the sky down to the horizon with a blue-dominant mix of Phthalo Turquoise and Permanent Red using horizontal strokes of a ½" angle brush. You'll need a lot of water in this mixture. Winter skies are softer and have less color in them than summer skies. Keep your strokes loose and blended and be sure to leave white areas for the trees.

Add watered-down Cobalt Blue to the areas next to the trees and above the adobe roof.

Imply clouds by touching a brush wet with clear water to the sky to create runs. You can also blot the still-wet surface with a bit of paper towel to remove pigment in the cloud areas.

If you make a mistake, add water to the area with a big brush and blot with clean paper towel.

For the windows, create a dark, red-dominant mixture of Phthalo Green and Permanent Alizarin Crimson. Paint them in using the ¼" angle brush of the no. 6 round. If the edges bleed or look textured, wait until the paint dries and then clean up the edges with a clean, wet brush.

PHTHALO GREEN +
PERMANENT ALIZARIN CRIMSON

PHTHALO GREEN + PHTHALO TURQUOISE

COBALT BLUE + PERMANENT ROSE

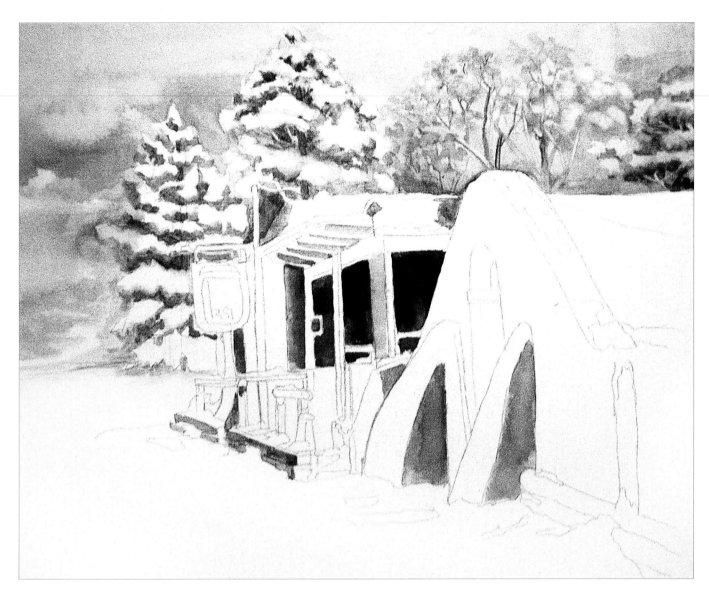

Step 3

Paint the trees

The white snow will be the white of the paper. To give the snow form, paint the pine tree branches underneath the snow with a dark, green-dominant mixture of Phthalo Green and Phthalo Turquoise. Some of the snowy branches may overlap the Cobalt Blue background a little. Don't make the dark bands of branches perfectly horizontal. After the paint has dried, you can soften edges and create transitions with a clean, wet brush.

Use the rigger brush to paint the bare tree branches above the adobe roof. Starting at the roofline, pull the brush up to make the limbs. Practice first on a scrap of paper — although you can remove mistakes in the branches from your painting, you may also remove part of the sky.

Lighten some parts of the branches with a clean, damp brush. Add suggestions of leaves with the ¼" angle brush and watered-down Quinacridone Gold.

Step 4

Paint the shadows on the adobe

The supports for the adobe fence are in shadow, so paint them with several variations of blue and purple made from Cobalt Blue and Permanent Rose. The colors in other shadow areas of the building, including the wall behind the sign, are the same. Use your dark mixture of Phthalo Green and Permanent Alizarin Crimson to paint the boards under the hitching posts in front of the adobe.

Mix Permanent Alizarin Crimson and Quinacridone Gold for the warm shadow areas on the adobe walls and window frame. Brush over these colors with Burnt Umber.

The overhang above the windows is made up of logs. Paint them with blue-dominant mix of Cobalt Blue and Permanent Rose, leaving a white highlight to the right of each shadow shape.

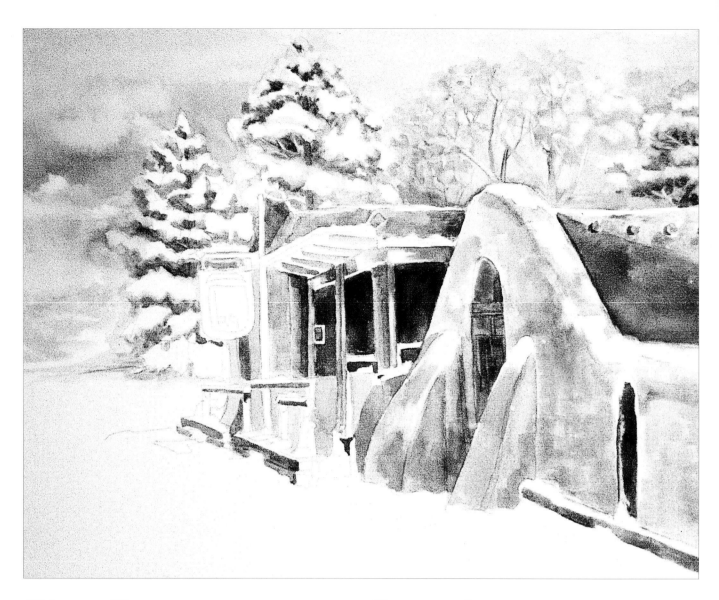

Step 5

Paint the warm colors on the adobe

The colors on the walls in direct light are warm. Create several individual color mixes by adding Permanent Rose, Permanent Red, Bordeaux and Permanent Alizarin Crimson each to Quinacridone Gold. Create another set of mixes by adding each of these same colors to Cadmium Yellow Light. (See the chart on page 46.) Mix and match these colors without blending on the adobe walls and fence. This gives the walls interest and sparkle. Paint around the snowy areas.

The darkest colors in the shadows and windows are cool mixes of Phthalo Green and Permanent Alizarin Crimson or Phthalo Green and Bordeaux.

Paint the small areas of logs with a mix of Burnt Umber and Permanent Alizarin Crimson using a very small brush. Use the same mix for the opening and gate in the adobe fence.

Step 6

Finish the adobe

The wall behind the coyote fence has a sharp line between areas of light and shadow, as well as several round shapes along the top. Paint the area in the light with warm colors, then paint the shadowed area with a combination of cool and warm, dark colors. Paint in the round shapes with a detail brush and dark paint after the wall is thoroughly dry.

Add a warm glow to the inside of the arch with Permanent Rose.

Paint the shadow areas of the wooden logs that make up the window frames and hitching post area with a cool, dark color. Paint the lighter areas with a mix of Permanent Alizarin Crimson and Quinacridone Gold. Use a detail brush to paint the sign, vaguely suggesting words or symbols.

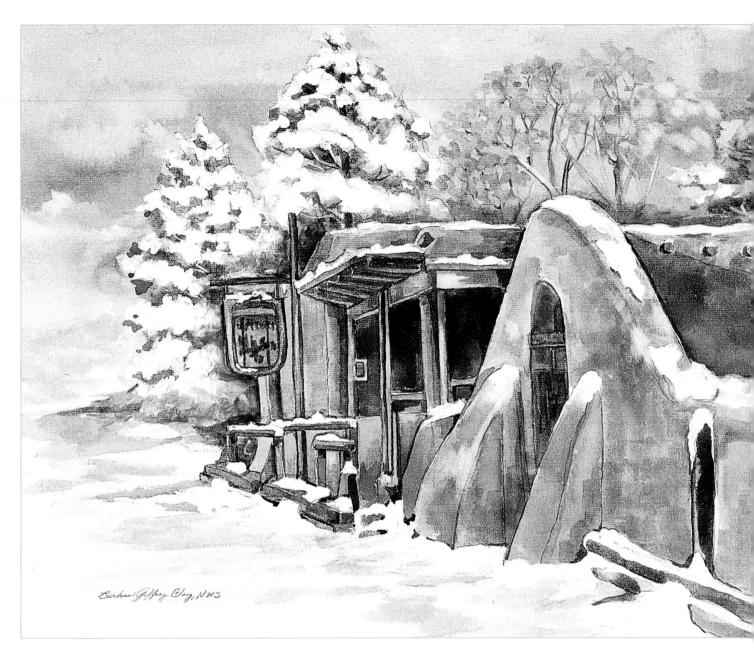

Step 7

Add dimension to the snow

Paint an uneven, watery wash of warm tones near the horizon at the left edge of the painting. Add another light wash of blue-purple to the snow in front of the adobe. Fill the remaining area with another varied light wash of color.

When the painting is completely dry, add texture to the snow by applying opaque white gouache thickly to the snowy areas on top of the adobe building, fence and logs.

Once your painting dries completely, seal it with acrylic spray.

Curved strokes like this work well on the adobe walls.

TIP

Since the adobe is your center of interest, it should have the most detail and sharpest brushstrokes. The trees should have less detail than the adobe, but more than the sky. This change in level of detail helps create depth in your painting.

PROJECT 6 HIDDEN BROOK

Painting Water and Dappled Sunlight

The effect of dappled sunlight is often difficult to achieve, especially as it bounces off the surface of moving water. This project will help you learn how to paint sunlit reflections, flowing water, autumn colors, bare tree branches and the effect of sun shining into a shady area.

The challenges
- choosing realistic colors
- painting flowing water
- rendering rocks and bare tree branches

What you'll learn
- how to create mood with color
- how to create the effect of depth in water
- how to use rigger brushes for thin, twisty, curvy lines

The techniques you'll use
- applying masking fluid by spattering
- creating texture with plastic wrap
- mottling color with salt

Using rigger brushes
Rigger brushes have very long bristles and will hold a lot of paint. They're good for curly vines and bare tree branches. Load the brush with paint, touch the bristles to the paper where you want the vine or branch to begin and twist the brush as you pull to get the effect you want. Practice until you feel you have some control over how the paint is applied. I painted the examples below with three different brush sizes.

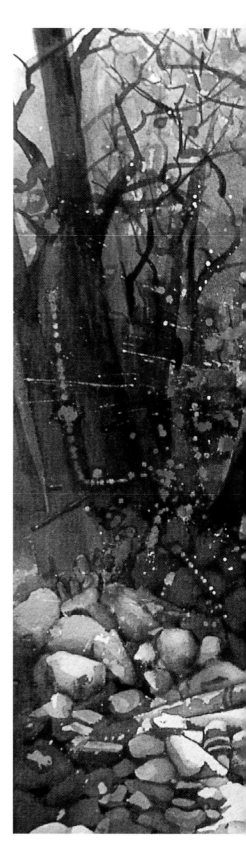

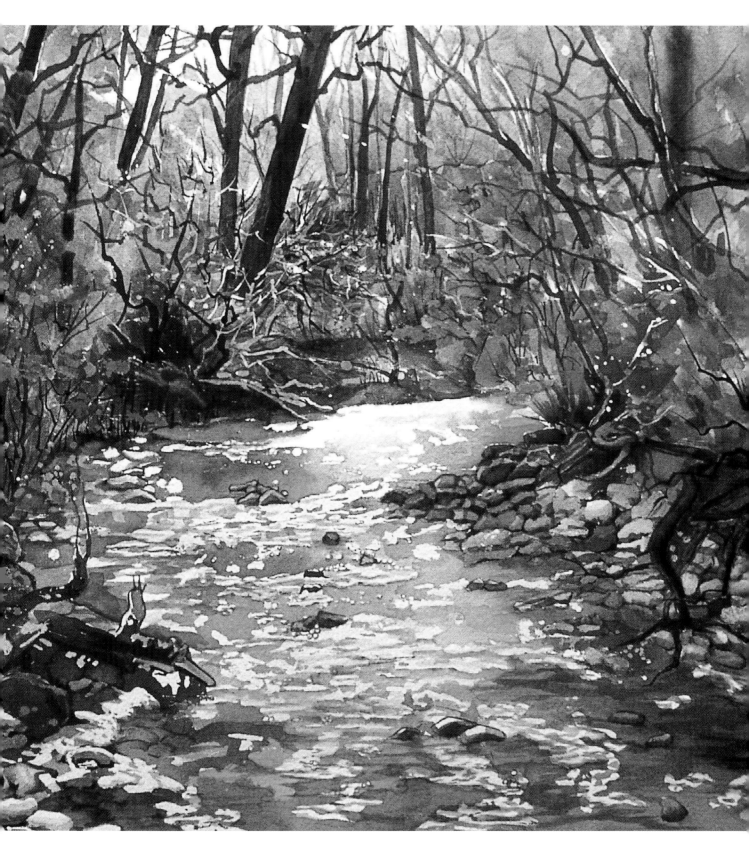

Hidden Brook, watercolor, 16 x 21" (41 x 53cm)

The materials you'll need for this project

Support

You will need artist-quality 140lb (300gsm) cold-pressed watercolor paper.

Pencils and paper

Use a no. 2 pencil or graphite paper to transfer the drawing onto your watercolor paper.

Brushes

- nos. 6, 8 and 12 synthetic rounds
- ¼", ½" and 1" angled brushes
- small round detail brush
- nos. 1, 4 and 6 rigger brushes

Other materials

- Always keep a good supply of high-quality paper towels and clean water.
- White masking fluid helps preserve the whites in this painting. Remove it with a rubber cement pick-up.
- We will be creating texture with clean plastic wrap and table salt.
- Opaque white ink can be used to make corrections and add highlights. I used it with a rigger brush in this painting to create light branches.

Watercolors

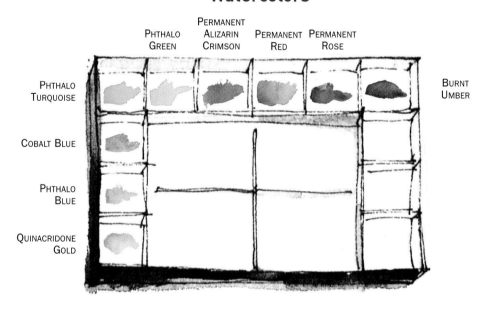

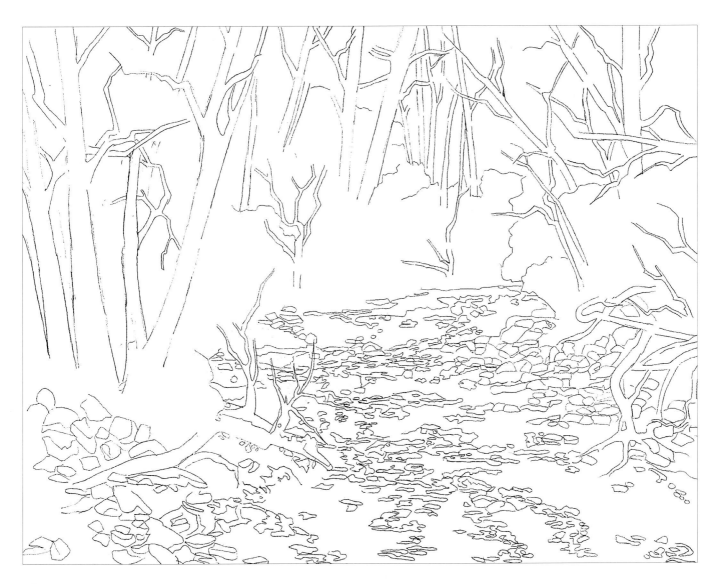

Step 1

Get ready to paint

Name your painting and think of words to describe its subject matter and the way it makes you feel: bubbling brook, peaceful, serene, autumn.

Photocopy and enlarge the drawing to the size you wish to work with. Place graphite paper between your support and the photocopied drawing. Trace over the photocopy, lifting the graphite paper periodically to make sure you're not missing anything.

If you wish, you may also transfer the drawing without graphite paper by taping the photocopy to a window or lightbox. Tape the watercolor paper over the top, and trace.

Use a no. 2 pencil or mechanical pencil with soft lead. Any pencil marked with an H will be too hard and it will scratch the surface of your paper. Be careful as you transfer the drawing — too much erasing on watercolor paper can cause the paint to blotch later.

Step 2

Apply the masking

Use a white masking fluid to preserve the white in your painting. Use an old or inexpensive brush to apply the masking fluid, coating it first in liquid soap. Be aware that you will not be able to reuse the brush for painting. For really tiny areas, use a toothpick or pen nib to apply the masking. Don't bother to mask large white areas — you can paint around them.

For this painting, I also spattered masking fluid onto the paper with an old toothbrush. Protect your clothes, furniture and rugs before you spatter, because masking fluid can't be removed from fabric or rugs. Spatter both horizontally and vertically.

Wait until the masking fluid is dry before continuing with your painting. Don't use a hair dryer to speed the process because the heat can embed the masking fluid into the paper.

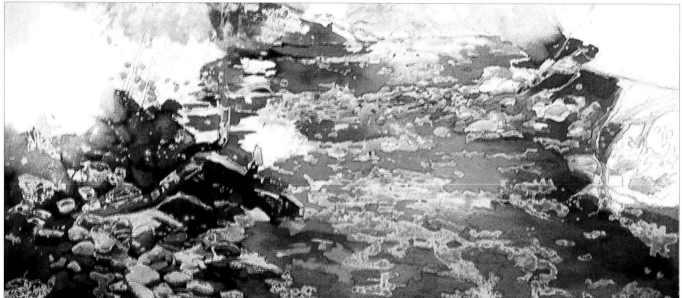

Step 3

Paint the water and large rocks

Unlike the still water of a lake, the moving water of this stream does not reflect the trees along its banks. Moving water reflects the sky color. The masking fluid on the paper will protect the white reflections of sunlight as you paint.

To give the water depth, paint the pebbles or sand on the bottom of the stream before you paint the water. The layer of blue paint that forms the water will make the rocks and sand look like they are under the surface. Use grays mixed from the complementary colors blue and orange (you can mix orange from Quinacridone Gold and Permanent Rose). Paint rocks darker at the bottom than at the top.

While the rocks are drying, paint the sand on the banks of the stream.

Paint the water with horizontal strokes of blues made from Phthalo Blue, Cobalt Blue and Phthalo Turquoise. Use Phthalo Turquoise in areas of bright sun — it has yellow tones that convey a sunlit effect. Paint the

water in shadow with a richer, darker Phthalo Blue. Add some of the gray rock colors to Phthalo Blue to create the softer hues along the bank and near the rocks.

Paint over the entire rock area with muted grays. The masking fluid will protect the white highlights. To give the illusion of three-dimensional form, each rock needs a minimum of three values: light (the area preserved by masking fluid), medium (the base gray color) and dark (found at the base and in the shadow of the rock).

Use brushstrokes that follow the form of the rock. These rocks are round, so your brushstrokes should curve around them. If you want to paint flat rocks, use flat vertical or horizontal strokes.

Vary the grays used in painting the rocks. Between the rocks, paint sand and shadows.

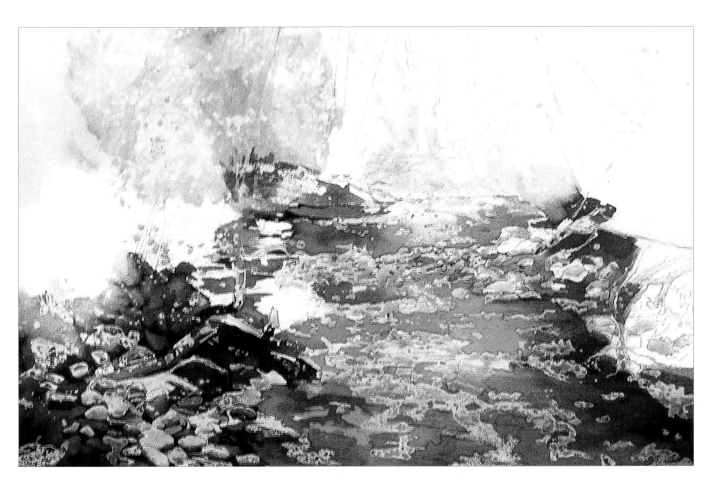

Step 4

Apply the background color and texture

Cut a piece of plastic wrap a bit larger than the size of the background area. Have a shaker of table salt ready to go. Use a large brush to paint the background with heavily diluted Quinacridone Gold. Work around the large trees to the sides and in the center.

Sprinkle salt over the wet paint. Lay the plastic wrap on top, crumpling it into random but primarily vertical folds. You can adjust it until you get a texture that looks like trees and branches.

Let the paint dry completely under the plastic wrap (at least 20 minutes). If you lift the plastic too soon, the paint will run and the texture will disappear. Lift just a corner of the plastic wrap to see if the paint is dry. If not, wait longer before you remove the plastic wrap. As the paint dries, the salt will absorb water and pigment, leaving light spots on the paper. These spots will contribute to the look of undergrowth When the paper is totally dry, brush off the salt and throw it away.

Color mixes for water

Color mixes for rocks

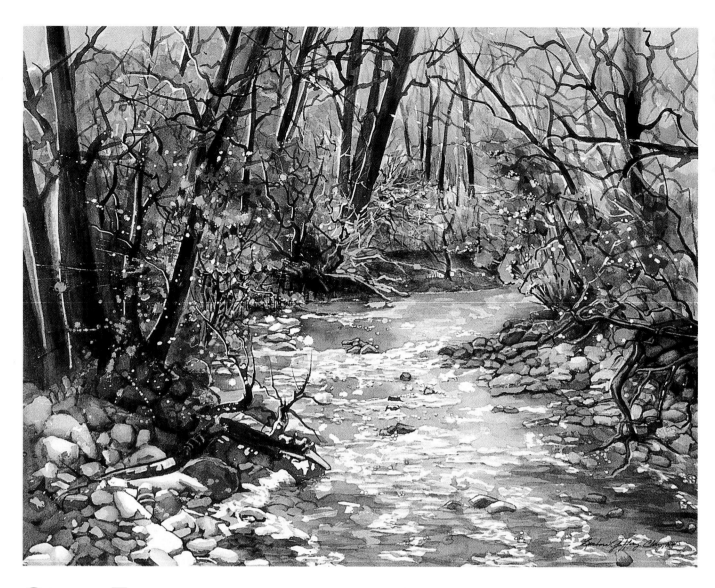

Step 5

Paint the stream banks

Paint the stream bank and rocks on the left side of the painting with warm colors mixed from Quinacridone Gold and Cobalt Blue, Permanent Alizarin Crimson and Burnt Umber. After the initial washes have dried, go back and add darker colors at the bottom of each rock to indicate form and shadow.

Mix several grays by adding Cobalt Blue to an orange made from Quinacridone Gold and Permanent Rose. Use these muted colors to paint the area of trees and undergrowth on the left side of the painting.

When the first background wash has dried, go back and add tree trunks with an angle brush and a dark color mixed from Permanent Alizarin Crimson and Phthalo Blue. Then start creating bare tree branches and shrubs with your rigger brushes. Use dark grays as well as brown mixtures of Burnt Umber and Permanent Rose. When you are satisfied with the branches, let them dry. Then, using opaque white ink on a rigger brush, add in even more skinny branches. Clean the brush thoroughly after using it with ink.

When the ink is dry, you can paint over some of it with diluted Quinacridone Gold. Do this only once, or you'll lose the effect.

Paint the stream bank on the right in the same way.

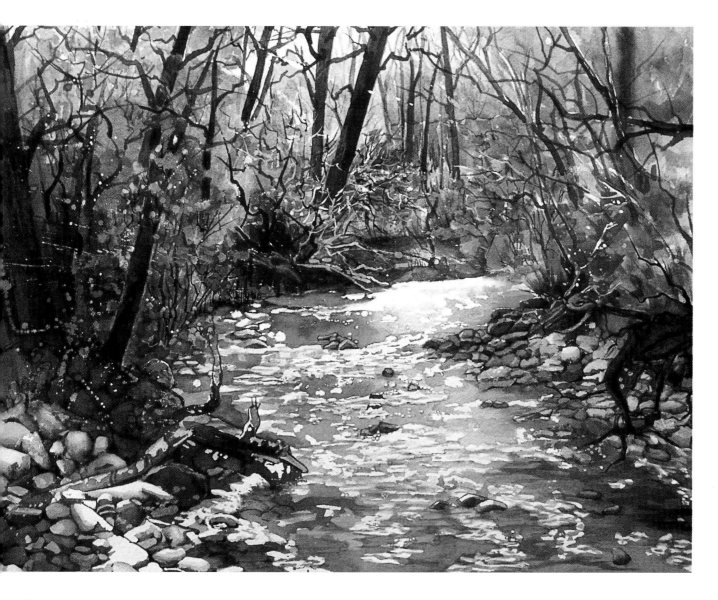

Step 6

Finish the painting

Allow the entire painting to dry completely, then remove the masking fluid. Check for unseen masking fluid by running your fingers over the paper.

Paint the masked-out tree forms with upward brushstrokes and a dark mix of Phthalo Blue and Phthalo Green. You can vary this mixture easily by replacing one of the Phthalo colors with Permanent Alizarin Crimson. At this point, you can also add more branches, remembering to stagger them so they will look more realistic.

Use heavily diluted blues to soften the hard edges created by the masking fluid in the stream area. Choose Phthalo Turquoise for the lightest areas and Cobalt and Phthalo Blue for shadow areas. As you work, check the edges of your brushstrokes. If you see a sharp, hard edge, soften it before you move on.

PROJECT 7 LILIES

Painting Depth in Layers

This project is painted in layers starting with the background and moving forward to the lilies. This approach is particularly useful when the subject contains a lot of white. It can be a challenge to paint the background first, so take special care with your drawing. A well-planned project is easier to paint and much more fun!

Another challenge in this project is painting with a very wide variety of greens and other colors. We will be mixing greens, using colors right out of the tube, and mixing colors with their complements. The variety of color helps make this painting interesting and visually engaging.

The challenges
- starting a painting with the background, rather than the subject
- painting a complicated background
- using color and value to create both depth and a sunlit feel

What you'll learn
- how to combine strong verticals with circular shapes
- how to keep a repetitive design element (in this case, the stems in the background) interesting
- how to draw attention to the subject and away from a busy background

The techniques you'll use
- masking
- directional brushstrokes
- color mixing

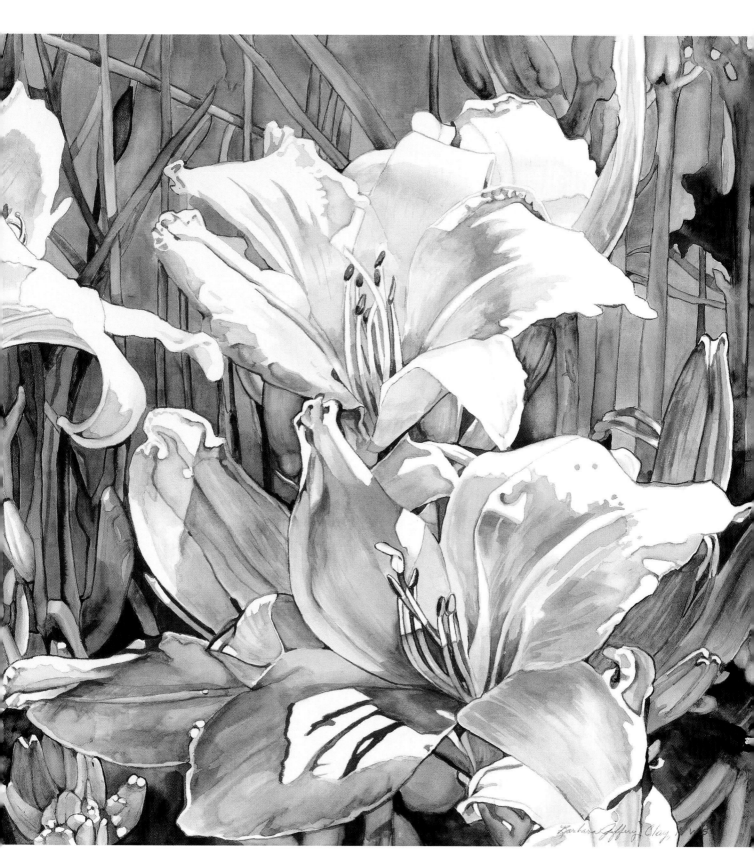

Arroyo Seco Lilies, watercolor, 22 x 30" (56 x 76cm)

The materials you'll need for this project

Support
You will need the whitest 140lb (300gsm) cold-pressed watercolor paper you can find.

Brushes
- nos. 6, 8 and 12 synthetic rounds
- 1/4", 1/2" and 1" angled brushes
- small round detail brush

Pencils and paper
Use a no. 2 pencil or graphite paper to transfer the drawing onto your watercolor paper.

Other materials
- Always keep a good supply of high-quality paper towels and clean water.
- White masking fluid helps preserve the whites in this painting. Apply it with an old brush and toothpicks. Remove it with a rubber cement pick-up.
- I used a pink colored pencil to clean up some edges when the painting was almost finished.

Watercolors

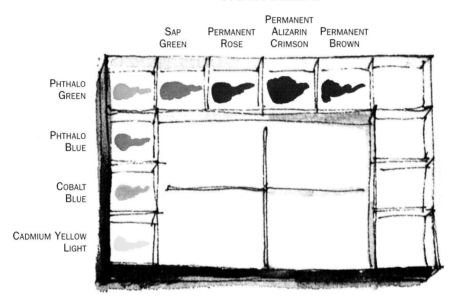

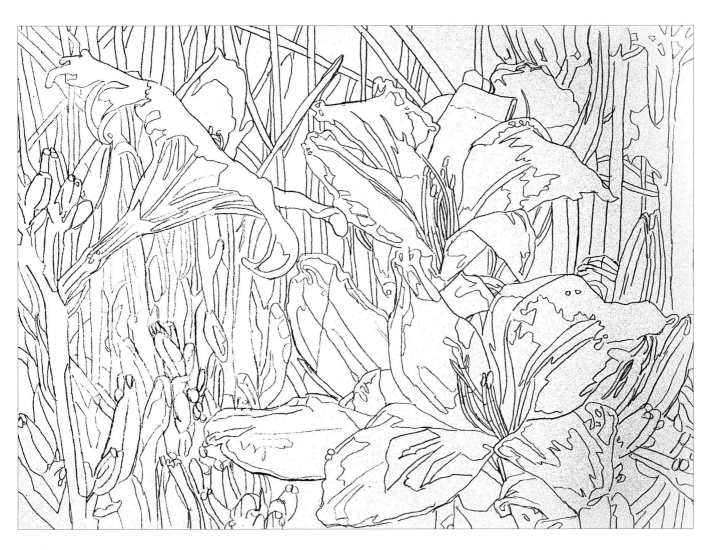

Step 1

Get ready to paint

Name your painting and think of words to describe its subject matter and the way it makes you feel: vibrant, brilliant, sunlit.

Photocopy and enlarge the drawing to the size you wish to work with. Place graphite paper between your support and the photocopied drawing. Trace over the photocopy, lifting the graphite paper periodically to make sure you're not missing anything.

If you wish, you may also transfer the drawing without graphite paper by taping the photocopy to a window or lightbox. Tape the watercolor paper over the top, and trace.

Use a no. 2 pencil or mechanical pencil with soft lead. Any pencil marked with an H will be too hard and it will scratch the surface of your paper. Be careful as you transfer the drawing — too much erasing on watercolor paper can cause the paint to blotch later.

Step 2

Apply the masking

Use a white masking fluid to help remind you that the masked areas will be white in your painting. Use an old or inexpensive brush to apply the masking fluid, coating it first in liquid soap. Be aware that you will not be able to reuse the brush for painting. For really tiny areas, use a toothpick to apply the masking. Don't bother to mask large white areas — you can paint around them.

Wait until the masking fluid is dry before continuing with your painting. Don't use a hair dryer to speed the process because the heat can embed the masking into the paper.

If you wish, you can apply 1" masking tape around the borders of the painting. This creates a clean finished edge. In this painting, the tape also provides vertical guides when you're painting the stems in the background.

Step 3

Paint the red in the background

Paint the background behind the stems using vertical strokes and a variety of both warm and cool reds. Refer to this photo frequently so you don't get confused by the relatively busy background. If you make a mistake, you can lift color from the paper with a thirsty brush — a brush dampened with clear water, then blotted.

You can use reds straight from the tube (tube color), add other colors to alter the reds, or mix the reds with other colors to create a new color. For instance, you might use Permanent Rose from the tube, add just a bit of blue to make a cooler red, or add even more blue to make a purple. Adding yellow to red will first make a warmer red, then orange.

When you have finished the red portion of the background, examine the vertical stem areas to make sure there is a clean, sharp edge between the white of the paper and the red background. If you leave red in a stem and then add green, the end result will be an unwanted brown. If necessary, lift color with a thirsty brush.

Allow the painting to dry before moving on to the next step. Dry paper will not feel cool to the back of the hand.

PERMANENT ROSE +
CADMIUM YELLOW LIGHT

PERMANENT ROSE +
PHTHALO BLUE

PERMANENT ALIZARIN CRIMSON +
PHTHALO BLUE

PERMANENT ALIZARIN CRIMSON +
CADMIUM YELLOW LIGHT

PERMANENT ROSE +
COBALT BLUE

PERMANENT ALIZARIN CRIMSON +
COBALT BLUE

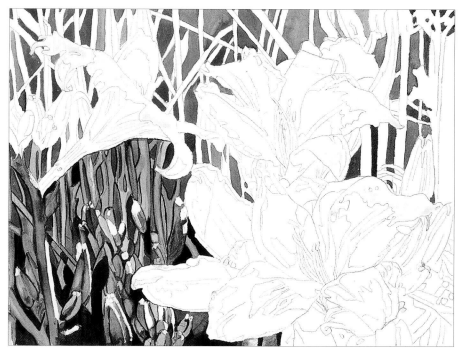

Step 4

Paint the background stems

As you paint the stems, mix a wide variety of greens: warm and cool, dark and light, bright and dull. You can mix greens from yellow and blue, use tube colors (greens right out of the tube) or mix tube greens with yellows, blues and even reds. Light yellow-greens are typical of new growth. Create darker and grayer greens by adding green's color complement, red.

Pay attention to the bud, leaf and stem structures. If necessary, use a reference book when you're painting so you can get the details right.

When the greens have all dried, you can glaze (layer) over select areas, such as the flower buds, with muted reds. Paint some of the flower buds in muted pink. The buds at the far right can be painted with sharper edges so they move forward in the painting.

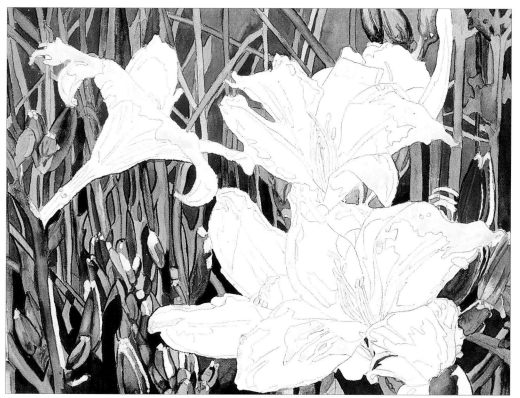

CADMIUM YELLOW LIGHT + PHTHALO BLUE

SAP GREEN + CADMIUM YELLOW LIGHT

SAP GREEN + PERMANENT ROSE

PHTHALO GREEN + PERMANENT ROSE

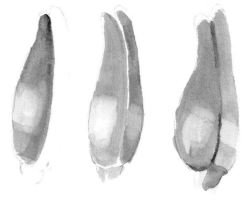

Lily buds usually show two or three individual segments. Paint each segment separately, using light and dark values to create the rounded forms.

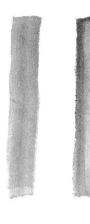

After painting a solid stroke of green for a stem, you can quickly and easily give it form by carefully dragging a clean, damp brush down just the middle of the stem. The thirsty brush will lift the color, creating a highlight that suggests roundness.

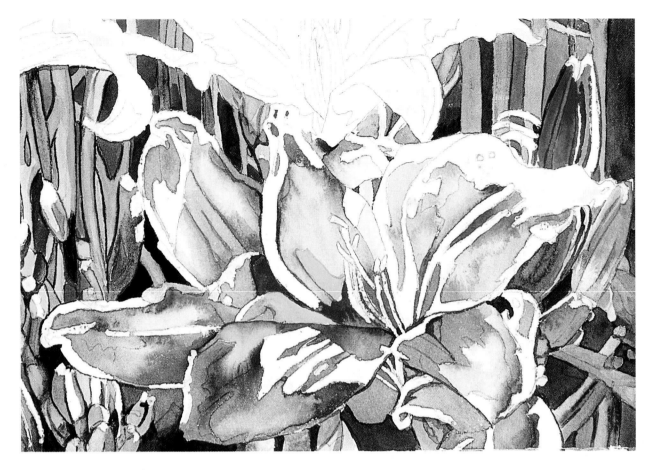

Step 5

Paint the center of interest

After the background has dried completely, check the pencil lines on the flowers. These lines are your color placement map. Lighten dark lines with an eraser, then whisk away the crumbs with a large brush.

All the colors in the flowers (except white) are mixed from Cadmium Yellow Light, Permanent Rose, Phthalo Blue, and Permanent Alizarin Crimson.

The flower at bottom right is the center of interest. It will be darker, brighter and more detailed. Paint each petal starting at the center and moving out. Lighten the color values for sunlit areas, and darken them for shadows, folds and creases. The edge of each petal have a darker line that should be painted with a small detail brush and dark pigment. Paint all areas of each petal not covered by masking fluid, then continue painting, petal-by-petal, in a clockwise direction.

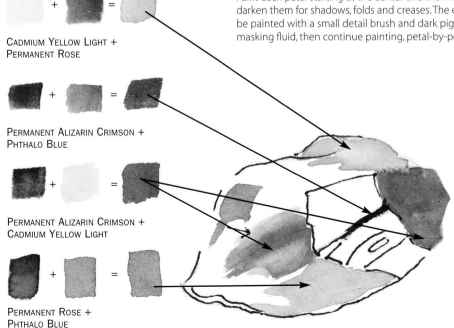

CADMIUM YELLOW LIGHT +
PERMANENT ROSE

PERMANENT ALIZARIN CRIMSON +
PHTHALO BLUE

PERMANENT ALIZARIN CRIMSON +
CADMIUM YELLOW LIGHT

PERMANENT ROSE +
PHTHALO BLUE

TIP

When you frame your painting, be sure to choose not only a frame and glass, but a mat. A mat will keep the surface of the painting from touching — and adhering to — the glass. You may wish to choose an archival mat, which will help keep the paper from yellowing. I think it's a nice touch to choose a double mat: a neutral-color on top, and a narrow strip of an accent color on the bottom, closest to the painting. Paintings always look more impressive when framed. Show your hard work off to your friends!

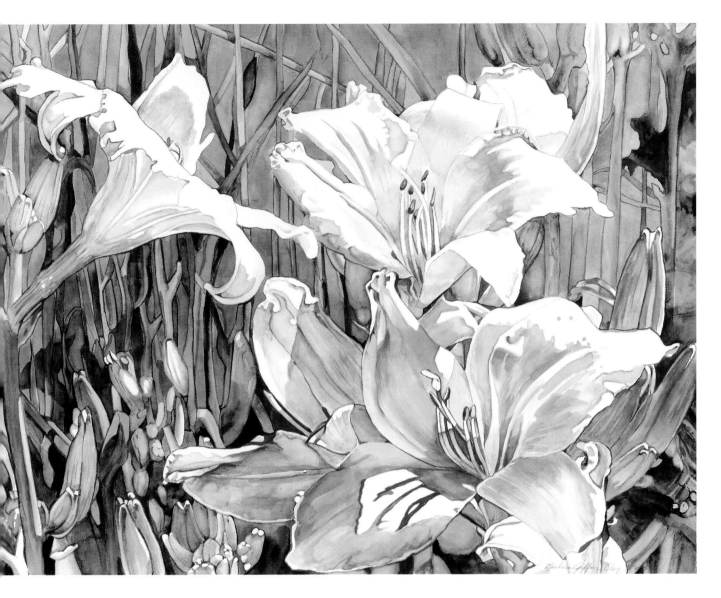

Step 6

Paint the two middle-ground flowers

The flowers at the top of the painting are closer to the sun and therefore lighter in value. They will have more white in them, and the colors used to paint them should be watered down so they are more pastel. An angle brush helps create smooth, clean-edged strokes. As before, paint from the center of the flower outward.

Step 7

Finish the painting

When the flowers have dried completely, remove the masking fluid from the background stem areas only. It's best to use a rubber cement pick-up designed for this purpose so you don't risk smudging the pigment on the paper. Paint in the yellow-green highlights on the background stems, then let the painting dry thoroughly.

Next, remove the masking fluid from the flowers and stamens. Clean up the edges with a pink colored pencil. Using a detail brush, carefully paint the stamens and anthers.

Step back and check the values in the painting. Make any necessary adjustments, then put the painting aside for a few days before you look at it again. This will give you fresh eyes for evaluating the painting one last time for any necessary finishing touches.

CADMIUM YELLOW LIGHT, PERMANENT ROSE AND PHTHALO BLUE

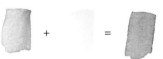

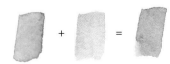

PERMANENT ROSE + CADMIUM YELLOW LIGHT

PERMANENT ROSE + PHTHALO BLUE

PROJECT 8 LANDSCAPE

Painting Distance in a Landscape

Vastness is the sense of unending space. You can achieve a sense of vastness and distance on paper by using perspective, a technique for drawing things smaller as they recede into the distance. You can also build the scene with overlapping elements to help the viewer see what is in the foreground, middle ground and background. Finally, you can mix the colors used in the background with their complements to gray them down. Muted, cool colors recede while warm, bright colors advance in the field of vision.

The challenges

- creating depth of field in a landscape
- mixing colors to visually recede or advance
- creating foreground, middle ground and background by overlapping elements

What you'll learn

- how to use perspective drawing to create the illusion of three-dimensional space
- how to mix complementary colors to gray them down or neutralize them
- how to paint a large wash for a sky

The techniques you'll use

- large washes
- preserving whites with masking fluid
- painting wet-on-dry
- painting wet-into-wet

Complementary colors

Complementary colors are those colors opposite each other on the color wheel. Placed side-by-side, these colors create intense visual interest and energy. Mixed on your palette, the colors neutralize each other. If you need to make a certain color more neutral or gray it down, add its complement.

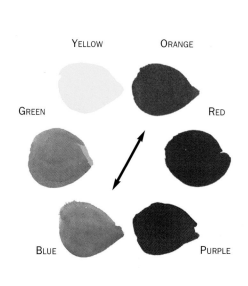

YELLOW ORANGE

GREEN RED

BLUE PURPLE

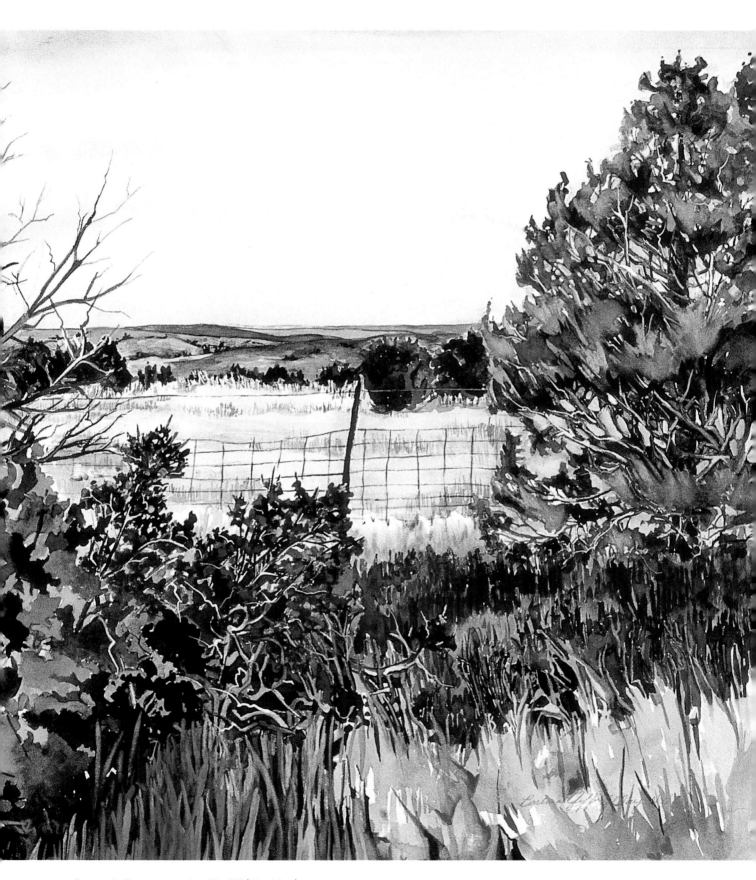

Roosevelt, Texas, watercolor, 20 x 25" (51 x 64cm)

The materials you'll need for this project

Support

You will need 140lb (300gsm) cold-pressed watercolor paper.

Brushes

- nos. 6, 8 and 12 synthetic rounds
- ¼" and ½" angled brushes
- 1" or larger synthetic flat wash brush
- small round detail brush
- small rigger

Pencils and paper

Use a no. 2 pencil or graphite paper to transfer the drawing onto your watercolor paper.

Other materials

- Always keep a good supply of high-quality paper towels and clean water.
- You will need a clean, non-staining, stiff board to support your watercolor paper.
- White masking fluid helps preserve the whites in this painting. Apply it with an old brush and toothpicks. Remove it with a rubber cement pick-up.
- I used opaque white ink to bring out some of the highlights.

Watercolors

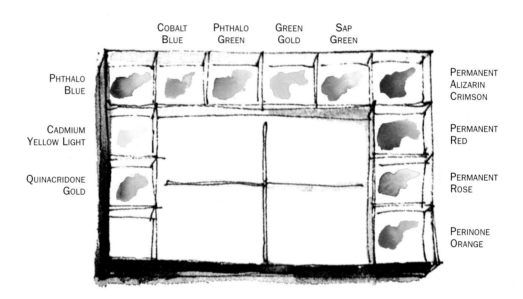

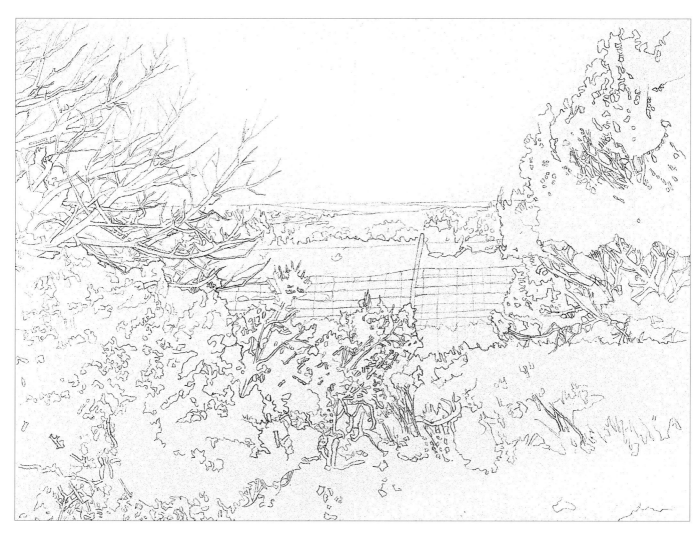

Step 1

Get ready to paint

Name your painting and think of words to describe its subject matter and the way it makes you feel: vast, faraway, expansive, distance.

Photocopy and enlarge the drawing to the size you wish to work with. Place graphite paper between your support and the photocopied drawing. Trace over the photocopy, lifting the graphite paper periodically to make sure you're not missing anything.

If you wish, you may also transfer the drawing without graphite paper by taping the photocopy to a window or lightbox. Tape the watercolor paper over the top, and trace.

Step 2

Apply masking fluid

Masking fluid is a rubbery liquid that prevents the watercolor paper from absorbing pigment. It is useful for preserving white areas that would be too small or difficult to paint around. In this painting, we need to preserve the bare tree branches in the foreground. Try to be very accurate as you apply the masking fluid.

If the masking fluid were dark, it would be difficult to assess value relationships while the masking fluid was in place. White masking liquid helps you to more accurately see values as you are painting.

Use an old brush and toothpicks to apply the masking. Keep in mind that a brush dipped in masking fluid won't be any good for painting. Some people rub soap into the brush before applying the fluid to make it easier to clean the brush and use it again for the same purpose.

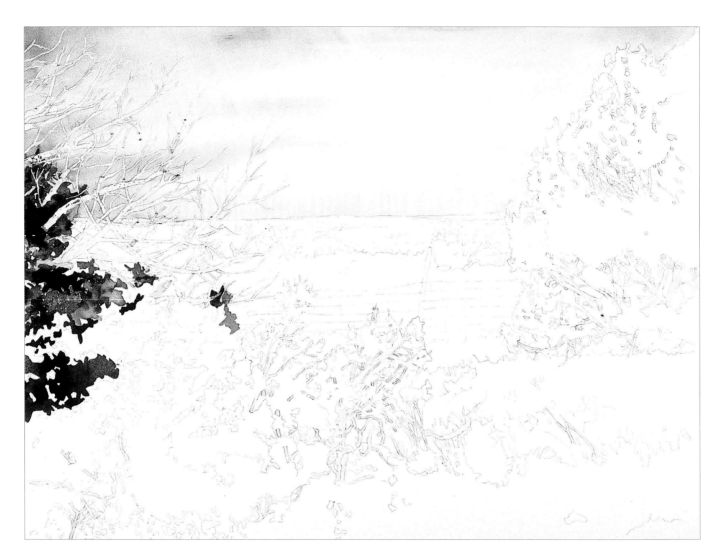

Step 3

Paint the sky

Begin the painting by applying a wash of clear water to the sky area, leaving some of the paper dry and white to suggest clouds. Apply the clear water right over the branches on the left, but paint around the tree on the right.

The branches on the left are covered with masking fluid. The clear water wash will puddle between the masked areas, so dampen a clean brush, blot it and use it to absorb excess water. A brush prepared like this is called a thirsty brush.

Apply paint to the dampened sky area with a 1" or larger wash brush. Start at the top and work down — this process is sometimes called window-shading. Skies are darker at the top and lighter at the horizon, so start the sky at the top with Phthalo Blue, allowing it to fade to clear as you near the horizon line.

When the paper is very damp but not shiny wet, add a diluted wash of Quinacridone Gold at the horizon to suggest a sunset. Because blue and yellow combine to make green, you don't want them to mingle on the paper or in your brush. Be careful to clean your brush thoroughly before switching colors.

To prevent blossoms and waterspots try not to go back into the sky colors until they are completely dry.

I got a head start on the foliage at left using dark mixtures of Sap Green with a bit of Permanent Rose.

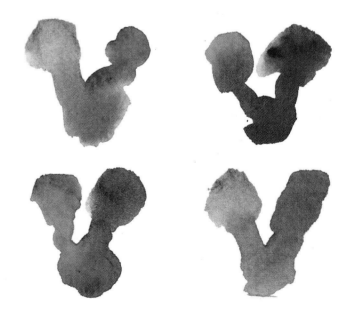

These are some of the color mixes I used to paint the tree at left.

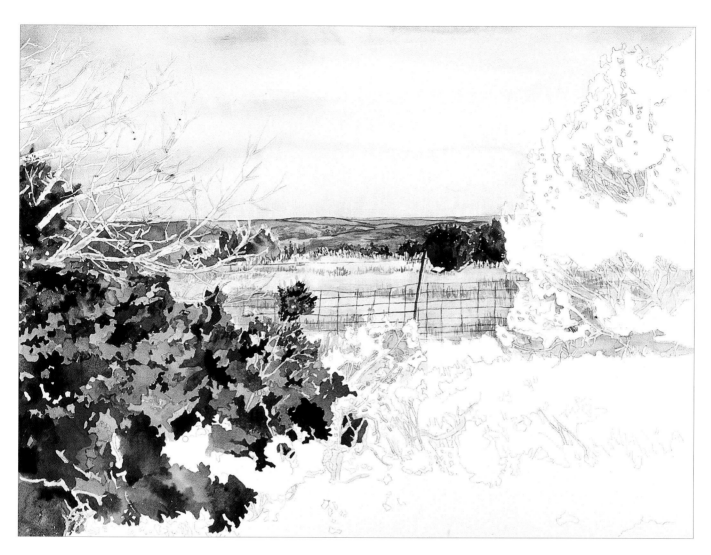

Step 4

Paint the distant hills and grasses

When the sky is completely dry, start painting the hills in the distance. Air molecules in the atmosphere cause visual interference over long distances, so objects in the distance appear cool and even gray in color with no details in the shapes. A mountain covered with green trees will appear purple and then blue as you get farther away from it.

To paint the mountains farthest away, create a mix of Phthalo Blue plus an orange made from Permanent Rose and Quinacridone Gold. Add just enough of the orange mix to mute the blue.

The mountains just in front of the blue ones are a purple mixed from Permanent Rose and Phthalo Blue. Add just enough Quinacridone Gold to soften the color.

Now it's time to move on to the small bushes at the far edge of the distant field. Paint them with a small detail brush and Sap Green mixed with a bit of Permanent Alizarin Crimson.

Paint the golden field with an angle brush. Use Quinacridone Gold, mixing it with some Permanent Alizarin Crimson in some areas for variety. Leave some of the white paper to suggest light hitting the field. Upward strokes of darker color suggest grasses in the middle ground.

Use interesting, colorful shapes for the focal-point tree.

Step 5

Paint the center of interest

The tree on the left is the center of interest, so it should contain more hard edges, the greatest variety of color, the most interesting shapes and the most detail. It is also much closer to the viewer, so it should be painted in brighter, more pure colors. Use variations and mixes of Sap Green, Phthalo Blue, Cobalt Blue, Phthalo Green, Green Gold, Quinacridone Gold and Permanent Alizarin Crimson. Wet a small shape with clear water, then drop in the color. In some sections, add more than one color to a pre-wet section and allow the paint to blend on the paper. To keep the shapes distinct, let each small section of color dry before painting the one next to it.

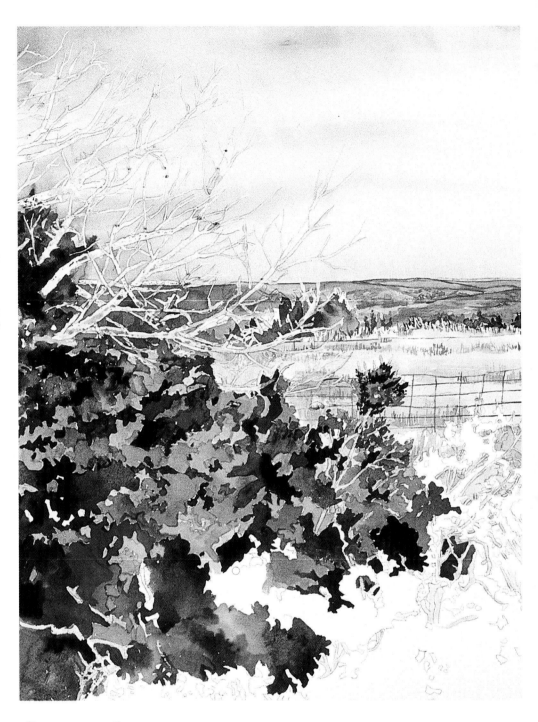

Step 6

Paint the fence

When the paper is once again completely dry, use your smallest detail brush to paint the fence with a mix of Permanent Alizarin Crimson and Phthalo Green. Place a small piece of paper towel under your painting hand so you don't smudge the paint.

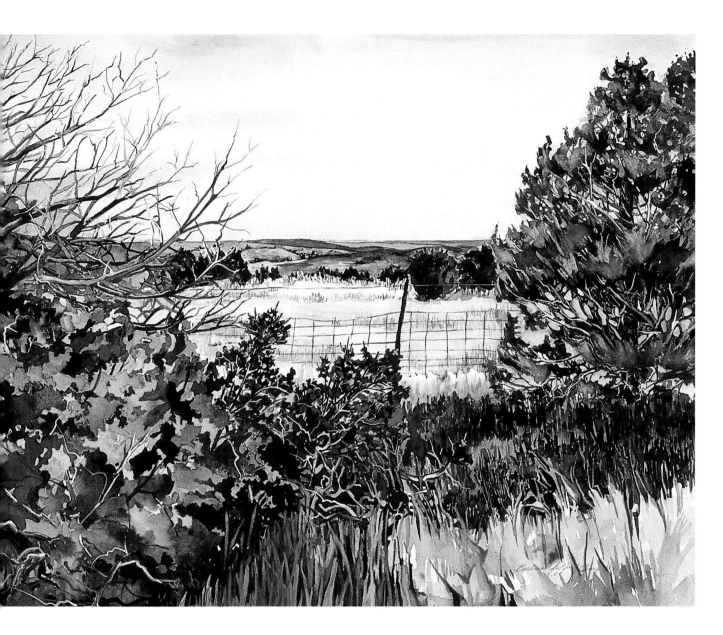

Step 7

Paint the details

Paint the grasses in the foreground with vertical strokes of a ½" angle brush. The grasses in the light are Quinacridone Gold. After the first layer of paint has dried, glaze the grasses with a mix of Quinacridone Gold, Permanent Alizarin Crimson and a touch of Cadmium Red.

Paint the grasses in shadow in blues and greens to add a cool note and tie all the colors together.

When the paper is completely dry, remove the masking fluid. Paint in the branches using a variety of medium to dark colors. For even greater detail, use white ink on a rigger brush to highlight the branches and create even more branches among the foliage.

Colors used for the grasses.

PROJECT 9 SUNSTRUCK AZALEAS

Painting Dramatic Florals

To be interesting to the viewer, every painting must have a range of values: lights and darks. Value changes create the illusion of depth by suggesting shadows and highlights. Values also create secondary shapes around and within the subject, defining the subject while adding interest. You can paint values with both warm and cool colors, combining value contrast and color temperature to heighten the illusion of dimensionality in your painting. The greater the contrast of values in your painting, the more dramatic your painting will be.

The challenges

- painting strong, abstract value shapes that do not detract from the larger shape of the flower
- creating the impression of light shining through translucent flower petals

What you'll learn

- how to create drama in your painting with value contrast
- how to add texture to your painting with plastic wrap

The techniques you'll use

- masking to preserve whites
- creating texture with plastic wrap
- wet-into-wet painting
- wet-on-dry painting
- using a thirsty brush to lift color and soften edges
- directional brushstrokes

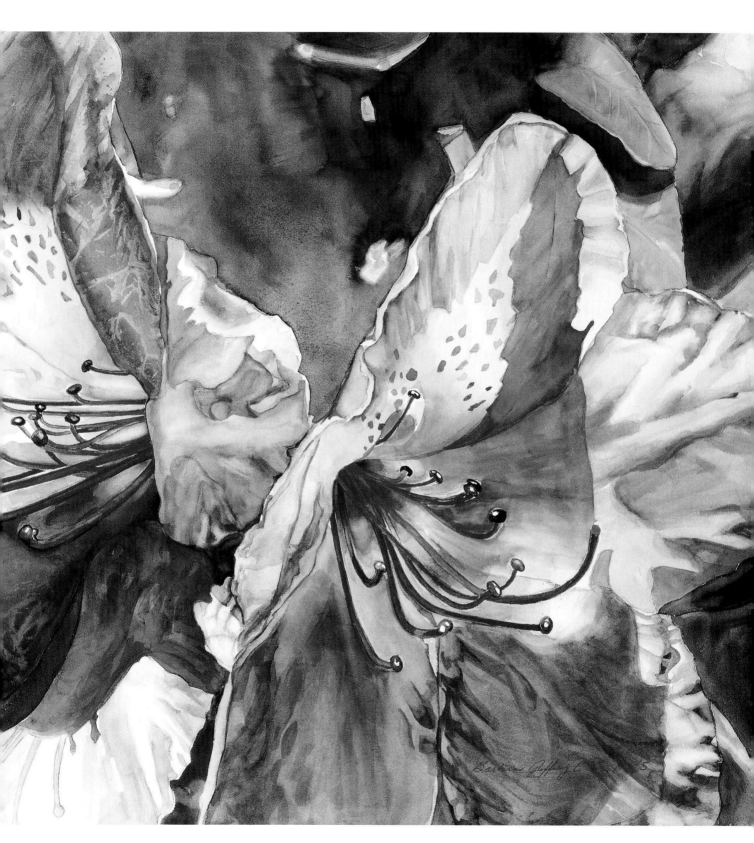

Theatrical Beauty, watercolor, 22 x 30" (56 x 76cm)

The materials you'll need for this project

Support

You will need artist-quality 140lb (300gsm) watercolor paper.

Pencils and paper

Use a no. 2 pencil or graphite paper to transfer the drawing onto your watercolor paper.

Brushes

- nos. 6, 8 and 12 synthetic rounds
- ¼", ½" and 1" angle brushes
- small round detail brush
- 1" (or larger) synthetic flat wash brush

Other materials

- I use plastic clips to hold my paper to a lightweight board while I'm painting.
- Always keep a good supply of high-quality paper towels and clean water.
- White masking fluid helps preserve the whites in this painting. Apply it with an old brush and toothpicks. Remove it with a rubber cement pick-up.
- I used a red colored pencil to clean up the edges of the long stamens.
- Use plastic wrap to add texture to this painting.
- Opaque white ink can be used to make corrections and add highlights.

Watercolors

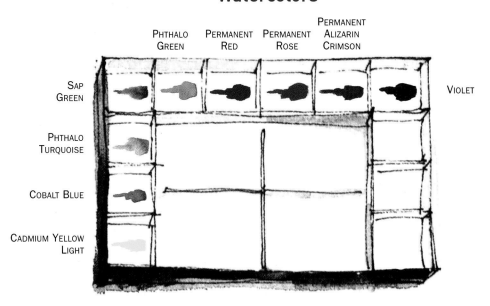

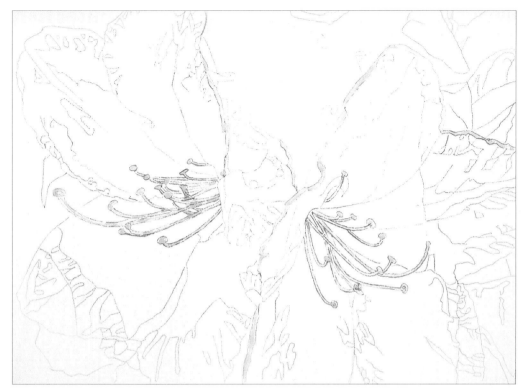

Step 1

Get ready to paint

Name your painting and think of words to describe its subject matter and the way it makes you feel: softness, drama, Spring.

Photocopy and enlarge the drawing to the size you wish to work with. Place graphite paper between your support and the photocopied drawing. Trace over the photocopy, lifting the graphite paper periodically to make sure you're not missing anything.

You may also transfer the drawing without graphite paper by taping the photocopy to a window or lightbox. Tape the watercolor paper over the top, and trace.

Use a no. 2 pencil or mechanical pencil with soft lead. Draw very lightly, and be careful as you transfer the drawing — too much erasing on watercolor paper can cause the paint to blotch later.

Step 2

Apply the masking

Use a white masking fluid to help remind you that the masked areas will be white in your painting. If the masking fluid were dark, it would be difficult to assess value relationships while the masking fluid was in place. White masking liquid helps you to more accurately see values as you are painting.

Use an old or inexpensive brush to apply the masking fluid, coating it first in liquid soap. Be aware that you will not be able to reuse the brush for painting. For really tiny areas, use a toothpick to apply the masking. Don't bother to mask large white areas — you can paint around them.

Wait until the masking fluid is dry before continuing with your painting. Don't use a hair dryer to speed the process because the heat can embed the masking into the paper.

You can also use a special masking fluid pen to apply thin lines of masking fluid.

Step 3

Paint and apply texture to the petals

Have a section of plastic wrap ready to go before you start painting. The piece should be slightly larger than the area where you intend to apply it.

Use your 1" wash brush to wet an area of one petal with clear water. Then paint this section with a mix of Phthalo Violet and Permanent Rose. (For a bluer mix, use more Phthalo Violet. For a mix that leans more to red, use more Permanent Rose.) Paint areas in shadow with cooler, darker colors. Areas in the light should be warmer and redder.

Now, place plastic wrap over the wet paint and scrunch it up. Bubbles and creases will appear where the plastic wrinkles and traps air, creating variegation in the paint underneath. While the paint is still wet, you can adjust the plastic wrap to form a texture pleasing to you that complements the larger petal shape. You can pick up and reapply the wrap at this stage if you need to. Try to prevent the wrap from sticking to the masking fluid — it could remove the masking before you're ready.

Wait until the paint is completely dry before you remove the plastic wrap. This will take at least 20 minutes. To check, lift just a corner of the wrap. If the color underneath starts to run, let the wrap sit longer. While you're waiting, you can paint and texture other petals, using a fresh piece of plastic wrap for each area. Work only on sections that don't touch areas that are still drying.

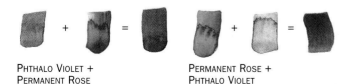

PHTHALO VIOLET +
PERMANENT ROSE

PERMANENT ROSE +
PHTHALO VIOLET

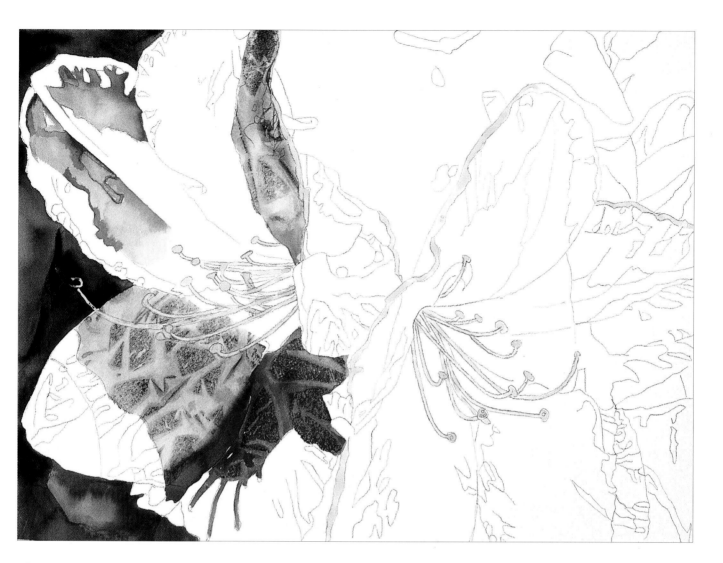

Step 4

Paint some petals wet-on-dry

Paint the petal in the upper left of the painting using pinks and purples. Instead of wetting the paper with clear water first, apply the paint directly to the dry paper. Vary the colors you use and allow them to mix at their edges. Use smooth, even strokes to contrast with the texture on the lower petals. For this flower, the color will be darker at the top of the petal and lighter near the center because the flower is backlit near the center.

The petal will have hard edges (hard edges occur where there is a crisp distinction between one color and the next) where it meets the background or another petal.

When the petals you have painted so far are dry, apply clear water to the background on the left side of the painting. Make sure you don't wet any of the flower petals with the water. Then drop or paint dark color mixes — blues, purples and greens — onto the wet paper. Applying some of the background color now will help you see the values in the painting more clearly as you proceed.

Dilute Permanent Rose with increasing amounts of water to create lighter values.

A change in value from one edge to another creates the illusion of three dimensions. The darker edges visually recede, while lighter areas come forward.

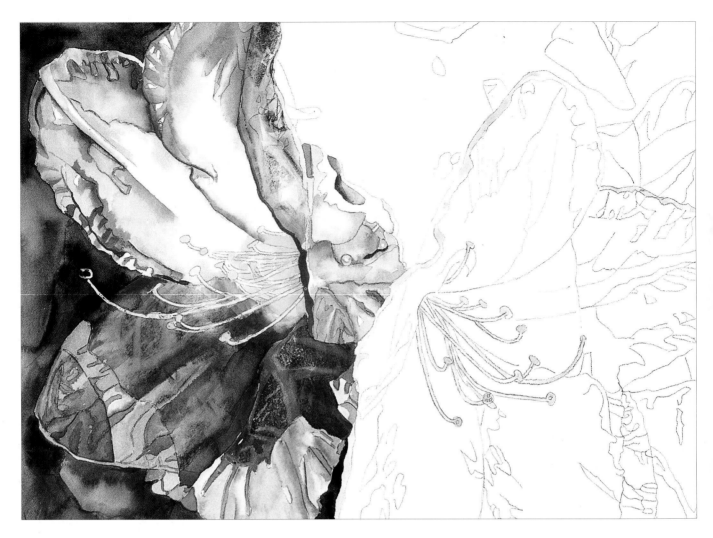

Step 5

Finish painting the flower on the left

Each petal has a central vein running vertically from the tip of the petal toward the center of the flower. To emphasize this feature, paint a strip of dark color to the left of each vein and leave the paper light or white on the right side of the vein.

Ruffles at the petal edges are created by alternating light and dark values of Phthalo Violet.

Paint the petals closer to the viewer with warmer colors of pink and purple. The petals further away should be painted with cooler purples and blues. Allow your brushstrokes to follow the shapes they are painting.

Glaze the lower petals with a wash of Phthalo Turquoise. The texture on the petals will show through. Where the light hits the two lower petals, use pale values of Permanent Rose.

Mix Permanent Rose with Phthalo Turquoise for some of the purples on the top petals. Paint the center of the flower near the base of the stamens

with Cadmium Yellow Light. To separate the flower petals from the yellow color, paint a line of Permanent Red where the rightmost petal curves outward toward the viewer.

Adjust the values on the petals, referring to the final painting and making sure you have a good combination of very dark to very light (or white) values.

When the petals are dry, add more color to the background. Petal-shaped areas of lighter color in the background suggest more flowers in the distance. Add green shapes mixed to suggest leaves. For variety in the leaves, create green mixes from Sap Green, Phthalo Green, Phthalo Turquoise and Cadmium Yellow Light. Once these background colors have dried, re-evaluate the darks in the flower petals and deepen them if necessary.

TIP

Create a "glow" by applying a drop of clear water to a still-wet area of Phthalo Turquoise on either flower. The light spot you create will glow like a bright, diffuse highlight.

PERMANENT ROSE +
PHTHALO TURQUOISE

PERMANENT ROSE +
COBALT BLUE

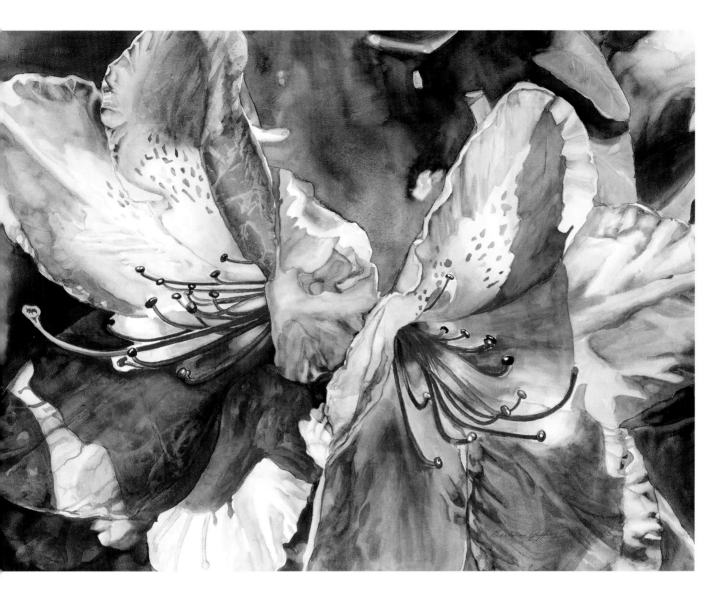

Step 6

Paint the flower on the right

Paint the flower on the right wet-into-wet with the same colors as the flower on the left. Include mixes of Permanent Alizarin Crimson, Phthalo Violet and Phthalo Turquoise. The very center of the flower is a very dark mix of Permanent Alizarin Crimson and Phthalo Turquoise, but the flower on the right should be lighter overall than the flower on the left.

Finish painting the background, and add darker shadow areas to the flower petals as necessary. If you need to brighten some of the lighter areas of the flower, lift paint with a brush dampened with clear water. Blot with paper towel to remove even more pigment.

Step 7

Finish the painting

When you are satisfied with the flowers and the background and the painting is completely dry, remove the masking fluid from the paper. Add color around the exposed areas of the petals, referring to the photo of my completed painting.

Add dots to the upper petals of the azalea blossoms. Only the three upper petals have these spots.

Paint the length of the stamens with Permanent Red. When they are dry, glaze over the bases of the stamens with Permanent Alizarin Crimson. Run the red colored pencil along the edges of the stamens to sharpen them.

Mix a very dark color from Phthalo Green and Permanent Alizarin Crimson and use this to paint the heads of the stamens. Leave a few white spots for highlights, or use opaque white ink to add the highlights when the stamens are dry.

Phthalo Green +
Permanent Alizarin Crimson

Phthalo Violet +
Permanent Alizarin Crimson

Phthalo Green +
Phthalo Violet

Phthalo Green +
Permanent Alizarin Crimson

PROJECT 10 PLUMBAGO

Using tiny shapes to form captivating large ones

This project will teach you accuracy and patience! Resist the temptation to hurry or you'll mess up the tiny flowers that make up the larger mass of flower shapes.

The challenges

- using many small shapes to make larger more interesting ones
- keeping both the large and small fragile shapes structured
- making large areas of dark color interesting
- creating interest in the light shapes

What you'll learn

- how to recognize shapes and their sizes, as well as their construction
- how to choose palette colors for the blues, using both warm and cool hues
- how to paint light shadows on small and large shapes

The techniques you'll use

- wet-in-wet
- direct painting
- masking fluid for different application
- lifting color with a paper towel
- negative painting
- colored pencil in conjunction with watercolor

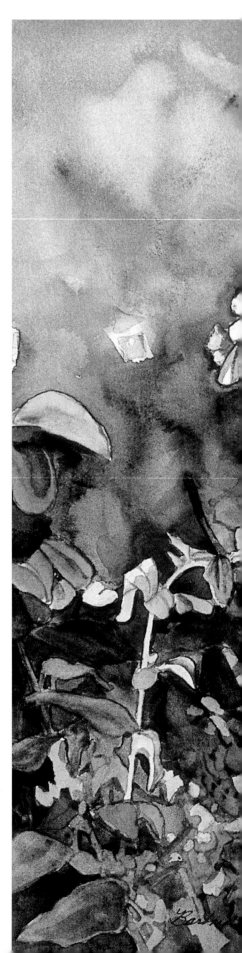

Plumbago Auriculate, watercolor, 15¾ x 18" (39 x 46cm)

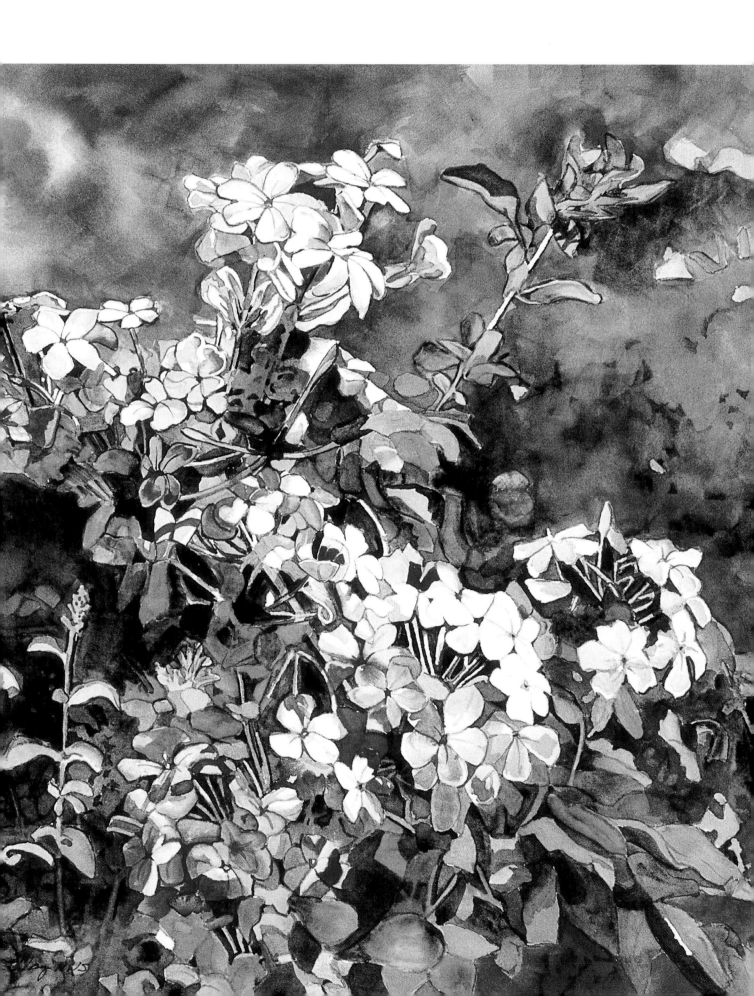

The materials you'll need for this project

Support

Artist quality cold-pressed 140lb (300gsm)
watercolor paper
Board

Pencils

#2 regular pencil or mechanical pencil
Blue and green colored pencils

Brushes

- #6, 8 and 12 rounds
- 1" flat or wash brush
- Angle brushes 1", ¹/₂" and ¹/₄"
- Small detail brush

Ink

I used opaque white ink to bring out some
of the highlights and make corrections.

Masking fluids

White liquid masking fluid
1" masking tape

Other materials

- Good, absorbent paper towels
- Plastic clips to hold the paper to the board
- White ink for corrections
- 2 plastic containers for water (one of clean
 water for mixing new colors, one for cleaning
 off brushes)

Watercolors

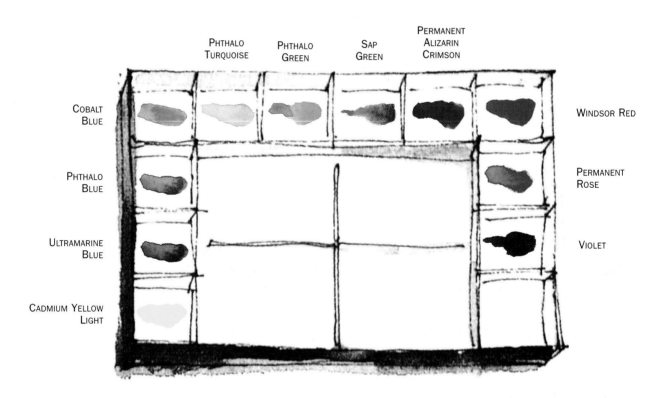

PHTHALO TURQUOISE PHTHALO GREEN SAP GREEN PERMANENT ALIZARIN CRIMSON

COBALT BLUE

PHTHALO BLUE

ULTRAMARINE BLUE

CADMIUM YELLOW LIGHT

WINDSOR RED

PERMANENT ROSE

VIOLET

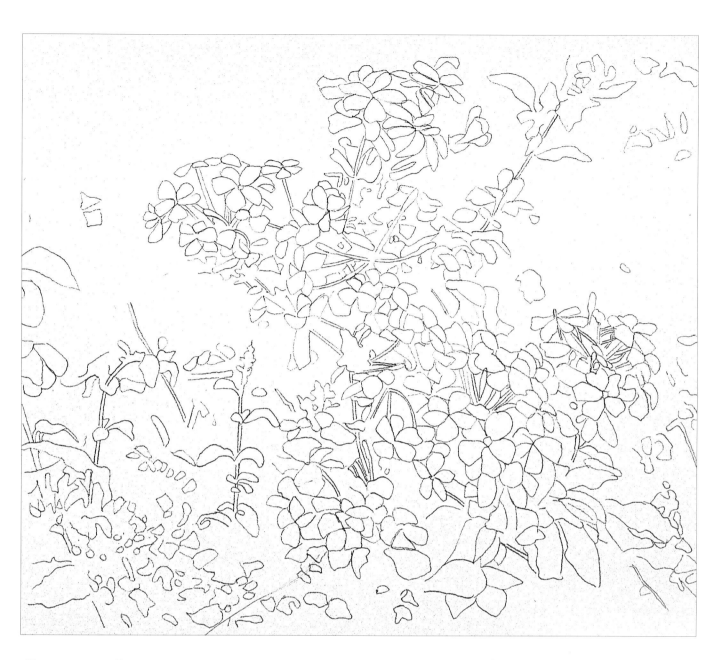

Step 1

Make a drawing

Using words to describe your feelings about this painting will help you focus on the project. The words I chose were delicate, old fashioned, charming, grandmother and fragile.

Sketch or photocopy and enlarge the drawing to the size you want to work with. Place graphite paper between your support (the watercolor paper) and the photocopied drawing. Trace over the photocopy, lifting the graphite paper periodically to make sure you're not missing anything.

If you wish, you may also transfer the drawing without graphite paper by taping the photocopy to a window or lightbox. Tape the watercolor paper over the top, and trace.

Use a no. 2 pencil or mechanical pencil with soft lead. Any pencil marked with an H will be too hard and it will scratch the surface of your paper.

Step 2

Apply the masking fluid

Small or even tiny areas of light, highlights and larger whites need to be preserved in the beginning. Large white areas can simply be painted around, but highlights on flower stamens and anthers are critical and need to be protected.

Allow the masking fluid to dry before continuing.

READ ME!

Remember to read through the project before you start so you know the order of play!

Step 3

Paint the flowers

- You are going to paint in the background using wet-in-wet techniques and bold colors.
- First, apply clear water into the background area, working around the flowers and leaves and all the drawing.
- Use your pointed brush to paint or drop in Phthalo Turquoise, Phthalo Green, Violet, Permanent Alizarin Crimson, Sap Green, Cadmium Red Light and Cadmium Yellow Light. Apply the rich, dark colors in random patterns.

- When paper is wet, cadmium colors tend to move lighter transparent pigments. In this case, Cadmium Yellow pushes the other colors and creates a pattern of blends.
- Still working with wet paper, roll the brush to lift the colors out in the upper left hand corner to create a soft light area.

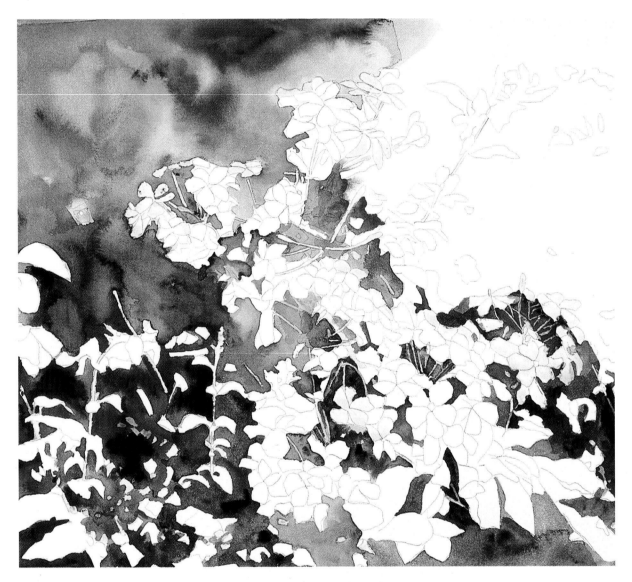

Detail
Cadmium Yellow pushes other pigments

Detail
Rolling the brush picks up paint and creates a soft, light area

Step 4

Now use the lifting technique and negative painting

While the paint in the background is still wet, scrunch up a piece of good quality paper towel and blot out some color. The creases in the paper towel create more patterns than can be achieved by simply lifting out with a brush.

Using the same colors in the background as before, paint around some of the light shapes — negative painting — to suggest organic growth. This gives more foliage pattern to the background and allows the imagination to see more things in the painting, making the process not only fun but easier.

Detail
Color lifted out with a paper towel

Detail
Color lifted out with paper towel and then negative painted to suggest forms.

Step 5

Paint the leaves

- Wait for the painting to dry. Then, before you start painting the leaves, remove the masking fluid.
- Paint the greens using yellows and blues, as well as greens that have been mixed with other colors.
- Use your angle brushes for the leaves, choosing bigger brushes for bigger leaves.
- Complete all the leaves in one area in different values and shades of green before moving to the next.
- Use Sap Green for the majority of leaves. Paint others using Cadmium Yellow Light mixed with Cobalt Blue or Phthalo Blue or even Ultramarine Blue. Remember that the more water you use, the lighter the hue of the green.
- Painting leaves is time consuming. Refer to the step picture to see where the lights and darks are. You'll be able to judge the values if you follow this order.
- Paint the edges of each leaf carefully. You might want to use a small detail brush to paint around the leaf shapes to keep crisp edges.

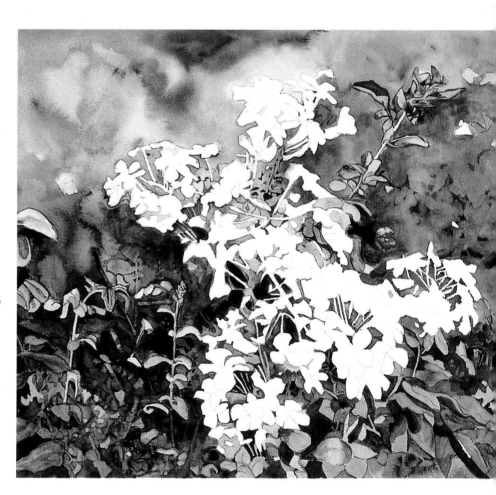

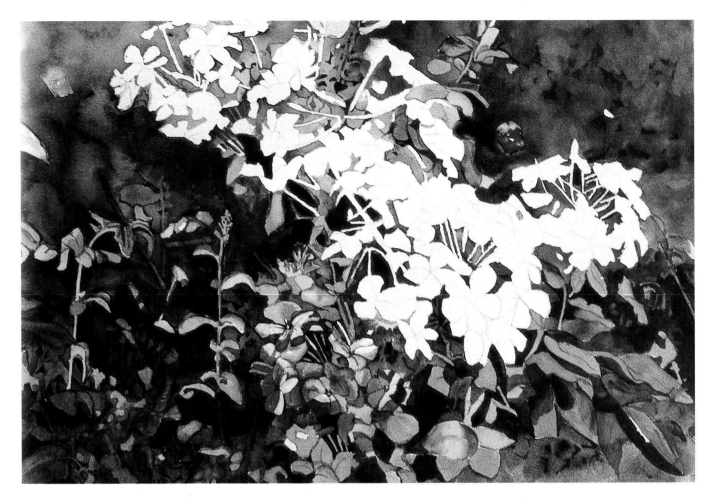

Make a "green chart" by combining all your yellows and blues.

Then add other colors to them. Red can make the greens grayer, blues can cool them, adding yellow makes a green warmer and lighter.

Step 6

Paint the flowers

- Remove the masking fluid from the flowers as you paint them.
- Plumbago have tiny blossoms that make up a larger mass of flowers. Combining shapes to make a larger shape means that each small shape needs to be the right value and color to give form to the larger blossom and add interest.
- Use both warm and cool blues and add purples for variety. Use light and dark and the white of the paper to make each shape perfect. Note the shape of the tiny flowers and how they may have shadow shapes across them.
- For a softer, non-obtrusive blue, add a little complementary color — orange.

Detail

Each flower has five petals. Each petal has a line down the center and each has a dark center. Accuracy is very important when you are painting real species of flower.

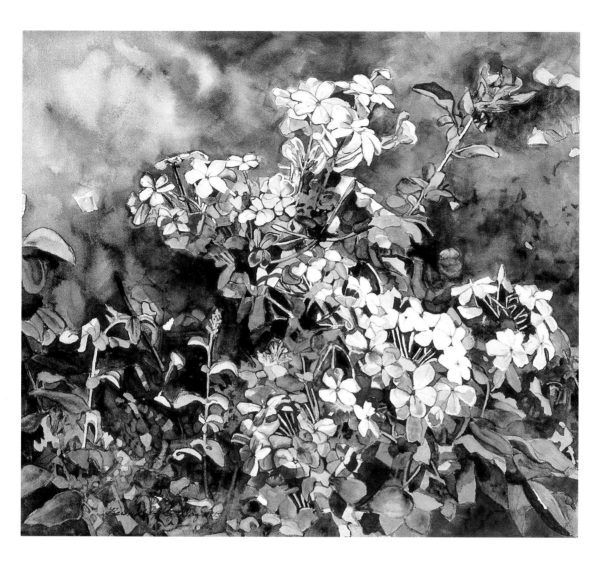

Step 7

Finish the painting

- Paint each flower individually using wet-in-wet for the blurry ones and direct painting for the highly detailed ones.
- Check the painting to see if you need to add more dark or more color. Place some small darks to add interest to the shapes. Place darks next to the slender stems holding the tiny individual flowers to give them emphasis. Glaze some of the leaves with Phthalo Green to create a brighter, more dramatic quality.

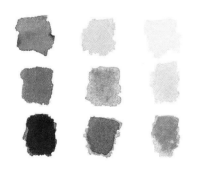

Blues watered down.

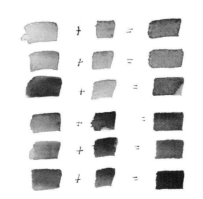

The same blues mixed with Alizarin Crimson Permanent and Permanent Rose.

READ ME!

Remember to leave some of the flowers in direct sunlight white!

Now you have completed all the projects in the book, go back and try them all again and see how much you have improved with practice!

LEARNING POINTS

☑ Design

Without a good design you can't create a good painting, no matter how well you have mastered the techniques. Before you put pigment to paper, take time to plan.

- Define your center of interest — the area of the painting with the most detail and the most contrast.
- Evaluate possible eye-paths to lead your viewer in and around your painting.
- Plan the values in your painting to strengthen the eye-path and center of interest.

Even when you can't wait to get painting, take a few minutes to plan. It's well worth the investment.

☑ Glazes (layers)

Layering — or glazing — is the application of additional washes of color over dry paint. Glaze when you need to

- intensify color or value
- change or create a color
- combine colors that would turn into mud if mixed on your palette

☑ Hard and soft edges

Painting presents many challenges. For instance, how can you convey the lovely contours, shapes and undulations seen in petals and leaves? Mastery of hard and soft edges is the key to painting three-dimensional subjects.

- An area of color with a very distinct and crisp edge is said to have a hard edge. Hard edges attract the eye and are often used at the center of interest and to separate the subject from the background.
- Soft edges are often called "lost." They are subtle transitions of color and can be used to represent curves and gentle shadow.

☑ Shadows

A good design incorporates dramatic shadows. Shadows lead the eye to the center of interest and provide the contrast that makes a painting interesting. When painting shadows, remember to

- establish a consistent light source
- use cooler colors when you want the shadows to recede
- include colors in your shadows

If you're painting outdoors or are using field sketches, make sure to take into account those constantly moving shadows. It's best to take backup photos to capture light and shadow patterns.

☑ Primary colors

Have you ever wanted to mix a special color, but had no idea how? Understanding how your pigments interact makes it easier to mix the colors you want. Start with just the primary colors (red, yellow and blue) to learn what your pigments can do.

- Learn which of your pigments are biased toward warm and cool colors.
- Then create a simplified palette from six colors — the warm primaries and the cool primaries.

☑ Color temperatures

Each color on the color wheel is considered either warm or cool. You can use color temperature in combination with value to give your painting depth. Watercolor pigments, however, are never pure colors from the color wheel. Learn the color bias of your pigments so you can more effectively give your two-dimensional painting a three-dimensional look.

- Warm colors — red, yellow, orange — seem to come forward in a painting
- Cool colors — blue, violet, some greens — seem to recede
- Individual pigments, themselves mostly either warm or cool, may also contain a secondary warm or cool component

☑ Complementary colors

One of the most dramatic of color schemes is the complementary color scheme. Complementary colors, when used together, have unique properties that can add interest to your painting and utility to your palette.

- Create interest and "vibration" by placing complementary colors next to each other.
- Complementary colors also brighten each other when placed side by side.
- Gray down a color by adding its complement.

☑ Value contrast

Value is the lightness or darkness of a color. Your paintings will have more depth if you use the full range of values.

- Squint at your painting to reduce it down to its basic values.
- A value scale can help you incorporate the full range of values in your painting.
- Although you don't have to use every value on a value scale, use at least a light, a medium and a dark.

☑ Learning from mistakes

The most important thing you need to remember is: Don't be afraid
of making a mistake. Most of them are fixable. I completed Project 7 in horizontal format only to discover it looked much better as a vertical painting. Watercolor is a vibrant, flowing medium that allows us to do things we can't do with any other medium. We may never fully master it, but we can sure have a lot of fun learning all its possibilities.

ABOUT THE ARTIST

American artist Barbara Jeffery Clay is a signature member of the National Watercolor Society, Southwestern Watercolor Society, the Texas Watercolor Society and the Watercolor Art Society, Houston. Her paintings have won many awards in exhibitions, including the Winsor & Newton Award at the National Watercolor Society (NWS).

Barbara's watercolors have been recognized by jurors and art collectors. She is also a respected portrait painter and her commissioned works hang in the Historical Museum in Galveston, Texas, at the Galveston-Houston Dioceses, Baton Rouge Chancery, Baton Rouge, LA; the Railroad Museum, Galveston, Texas and at St. Thomas High School and Rice University.

Her work hangs in galleries in Houston and San Antonio Texas, in Colorado Springs, Colorado and in Taos, New Mexico.

For over three decades, Barbara has taught oil and watercolor classes in the continuing education department at the University of Houston. She also teaches workshops around the US. Naturally, her experience has made her a sought-after juror for many exhibitions.

Barbara's floral work has taken her to many locations in Europe, and she has studied the botanical differences between flowering plants in Europe, Canada and Alaska. She uses her knowledge to add more beauty and color to her florals.

Visit her website at:
www.barbarajeffreyclay.com

What artists want!

If you liked this book you'll love these other titles written specially for you.

Artist's Projects You Can Paint

Each of the 10 thrilling step-by-step projects in these books gives you a list of materials needed, and initial drawing so you can get started straightaway. Dozens of individual color swatches will show you how to achieve each special mix. Clear captions for every stage in the painting process make this a fun-filled painting adventure.

- **10 Artist's Projects**
 FLORAL WATERCOLORS
 By Kathy Dunham
 ISBN: 1-929834-50-0
 Publication date: August 04

- **10 Artist's Projects**
 SECRET GARDENS IN WATERCOLOR
 By Betty Ganley
 Publication date: Spring 2005

- **10 Artist's Projects**
 WATERCOLOR TABLESCAPES LOOSE & LIGHT
 By Barbara Maiser
 Publication date: Spring 2005

- **10 Artist's Projects**
 MOUNTAIN SPLENDOR IN OIL
 By Betty J. Billups
 Publication date: Spring 2005

- **10 Artist's Projects**
 LANDSCAPE STYLES IN MIXED MEDIA
 By Robert Jennings
 Publication date: Spring 2005

Art Maps

Use the15 Art Maps in each book to get you started now!

Art Maps take the guesswork out of getting the initial drawing right. There's a color and materials list and there are plenty of tit-bits of supporting information on the classic principles of art so you get a real art lesson with each project.

- **15 Art Maps**
 HOW TO PAINT WATERCOLORS THAT SHINE!
 By William C. Wright
 ISBN: 1-929834-47-0
 Publication date: November 04

- **15 Art Maps**
 HOW TO PAINT WATERCOLORS FILLED WITH BRIGHT COLOR
 By Dona Abbott
 ISBN: 1-929834-48-9
 Publication date: October 04

- **15 Art Maps**
 HOW TO PAINT EXPRESSIVE LANDSCAPES IN ACRYLIC
 By Jerry Smith
 ISBN: 1-929834-49-7
 Publication date: December 04

How Did You Paint That?

Take the cure for stale painting with 100 inspirational paintings in each theme-based book. Each artist tells how they painted all these different subjects. 100 fascinating insights in every book will give you new motivation and ideas and open your eyes to the variety of styles and effects possible in all mediums.

- **100 ways to paint**
 STILL LIFE & FLORALS
 VOLUME 1
 ISBN: 1-929834-39-X
 Publication date: February 04

- **100 ways to paint**
 PEOPLE & FIGURES
 VOLUME 1
 ISBN: 1-929834-40-3
 Publication date: April 04

- **100 ways to paint**
 LANDSCAPES
 VOLUME 1
 ISBN: 1-929834-41-1
 Publication date: June 04

- **100 ways to paint**
 FLOWERS & GARDENS
 VOLUME 1
 ISBN: 1-929834-44-6
 Publication date: August 04

- **100 ways to paint**
 SEASCAPES, RIVERS & LAKES
 VOLUME 1
 ISBN: 1-929834-45-4
 Publication date: October 04

- **100 ways to paint**
 FAVORITE SUBJECTS
 VOLUME 1
 ISBN: 1-929834-46-2
 Publication date: December 04

How to order these books

These titles are available through major art stores and leading bookstores.

Distributed to the trade and art markets in North America by

F&W Publications, Inc.,
4700 East Galbraith Road
Cincinnati, Ohio, 45236
(800) 289-0963

Or visit: www.artinthemaking.com